WEDDING PHOTOGRAPHY
KICKSTART

How to Achieve Unlimited Success

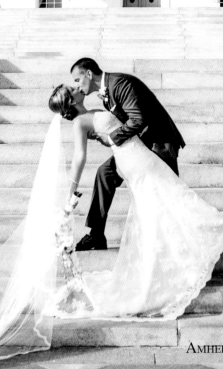

Pete Wright, *M.Photog.Cr., FP*
Liliana Wright, *Cr. Photog., AFP*

AMHERST MEDIA, INC. BUFFALO, NY

About the Authors

Pete and Liliana Wright are owners of PW Photography, established in 1997. After operating their studio in Virginia for seventeen years, they relocated their business to Florida, where they currently reside. Having photographed hundreds of weddings together, these two international award-winning photographers have honed their skills not only as artists, but as experts at branding and marketing a small business. Their artistic styles, while differing vastly from one another, have been brought together to form a perfect blend of vision and creativity, which allows them to present their clients with a more complete photographic experience. Pete and Liliana have lectured around the world together, sharing their experiences and how to succeed in an ever-changing industry. This is their first book together. This is Pete's second title from Amherst Media. His first book, *Cinematic Portraits: How To Create Classic Hollywood Photography,* was published in 2015.

Published by:
Amherst Media, Inc.
PO BOX 538
Buffalo, NY 14213
www.AmherstMedia.com

Publisher: Craig Alesse
Senior Editor/Production Manager: Michelle Perkins
Editors: Barbara A. Lynch-Johnt, Beth Alesse
Acquisitions Editor: Harvey Goldstein
Associate Publisher: Kate Neaverth
Editorial Assistance from: Carey A. Miller, Sally Jarzab, John S. Loder, Roy Bakos
Business Manager: Adam Richards

ISBN-13: 978-1-68203-048-6
Library of Congress Control Number: 2015916793
Printed in the United States of America
10 9 8 7 6 5 4 3 2 1

www.facebook.com/AmherstMediaInc
www.youtube.com/AmherstMedia
www.twitter.com/AmherstMedia

CONTENTS

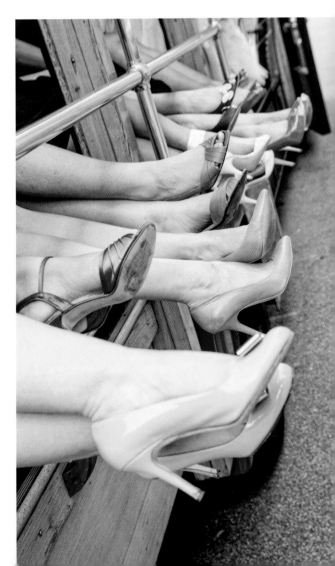

4. The Wedding Day 87

5. The Post-Wedding Phase . 113

The results of both of our lives and where we are today are directly related to the many amazing people we have been blessed to love, raise, and support us from the day we were born. Both of us have amazing mothers, Silvia Mora and Barbara Wright, who have molded us into the people we are today, have supported every decision we have made, questioned us when we needed to be, and loved us unconditionally the entire time. Our moms are at the very heart of who we are today, and we are blessed to have such strong women behind us.

Our children, Charlie and Caitlin, are the reason that we do everything and always have been, even before we knew they were going to be a part of our lives. We have been fortunate to have these amazing twins in our lives to drive us to be successful in our careers so that we can give them the future we want them to have and be given the gift of time to spend with them. Their laughter, joy, and inquisitive nature are what helps us through the hard times with a smile and always provides us with an abundance of amazing days that far outweigh the bad ones.

Charles Wright, although he has now passed, can be seen in our children every day. We hope that we can pass along so many of his life's lessons, including his love of photography, to our children.

Bekah Wright has been a constant source of encouragement for us. While she says that our lives inspire her, the truth is, it is her free spirit and her life's decisions to not be bound by anything and to constantly pursue her dreams that have pushed us to do the same. Our lives have taken us in directions that we were only brave enough to follow because of the courage we saw in her.

Clay Blackmore, having the opportunity to learn from you, work with you, and to know you as a friend has been invaluable. You singlehandedly opened our eyes to the potential of what could be achieved in our industry. Your constant success continues to raise the bar for us, giving us new heights to reach for. The time we spent with you showed us that we could make it as photographers and business owners and that we could flourish.

Thank you to all of the amazing photographers who we have had the privilege to call friends and learn from over the years. We have been blessed to be surrounded by such an amazing network of artists and generally great people. Many great photographers in our lives have been willing to share their knowledge to help us grow as artists and humans. This book would not be possible without each and every one of you. We are not the creators of any of these ideas, we are just vessels, and we have been fortunate enough to put them all to good use and find a combination of things that have worked well for us as a result of what we learned from all of you.

To all of the friends, family, and photographers who have supported us up until now and all of the ones who will in the future, we thank you all! God bless each one of you!

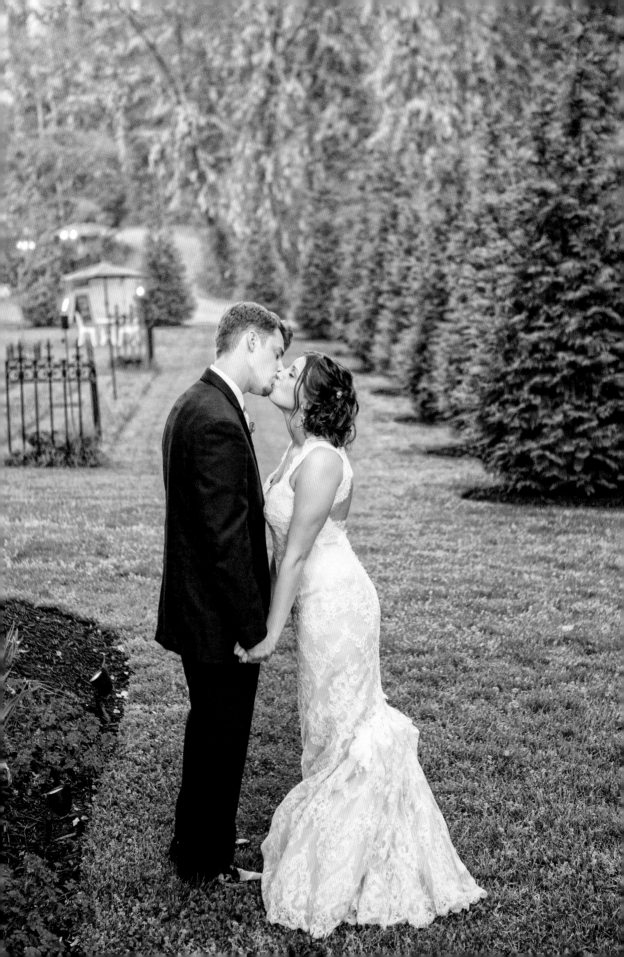

INTRODUCTION

Making the step into the wedding photography industry at first may seem like a quick and easy decision. The money that can be earned as a wedding photographer is undeniably appealing, but once you start making the necessary moves, you may realize there is a lot more to be done than you thought. This book is meant to be a step-by-step guide to help you work through all of the things you have thought of and a ton that you probably haven't.

We have been studio owners since the mid 1990s. When we decided to take on weddings, we did a ton of research into what brides and grooms expected to pay for wedding photography in our area and what they expected to receive. We have shot weddings all over the world for many years, and one thing we have learned is that prices and expectations vary widely from region to

region. Therefore, this book won't tell you what you should charge and include; rather, we will give some suggestions as to how you can set up your packages, and we will provide you with the information you need to determine how they should be priced for your region.

More importantly, this book will help you to avoid underpricing your services at the very beginning so that you don't have to face the uphill battle of raising your prices to the appropriate levels. Also, we will teach you how to position yourself so clients can easily find you and vendors can actively refer you. More importantly, we'll help you to ensure that your business is structured in such a way that you are easily able to exceed your prospective clients' expectations—so much so that they feel it would be a mistake not to hire you.

After you have found your clients, you need to have a great plan for execution on the wedding day. You will need, once more, to go above and beyond what your client wants. In addition, to set yourself up for success, you'll need to position yourself to provide your partner vendors with what they

previous page—Much like a couple starting their new life together on their wedding day, photographers face many challenges as they try to run a successful wedding photography business.

want. Of course, you'll also need to capture the publishable images that magazine and blog staff look for. This approach to weddings is cyclical in nature. The work you do on the wedding day leads to the referrals and visibility you need to book other weddings you want.

Solid branding is the key to tying this all together. Making decisions that ensure that your company is presented on the Web, in advertisements, and at bridal shows in the best-possible light is extremely important. Making sure that a potential client's perception of your business is what you want ensures that you are attracting the right type of bride and groom. We will help you avoid some common pitfalls and let you in on a few trade secrets that will move you ahead of your competition when potential clients are making their final booking decision.

Last but not least, we will cover much of the work that happens after the wedding. We'll offer advice on selecting the right products to offer your clients, interacting with them to select album images, creating their album design, and offering new products to increase your financial footprint with each client. We will also provide great tips for presenting new products to your clients in a way that doesn't feel like a sales pitch. In fact, we'll show you how to make your clients feel that you are presenting them with conveniences that make their lives easier.

below—Avoid pitfalls like underpricing or including too much in your packages when you start your business. *following page*—Marketing yourself so that you reach the right clients is key to the long-term growth of your business.

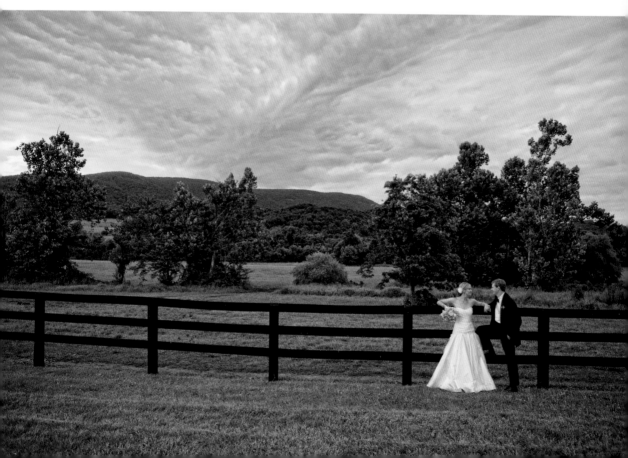

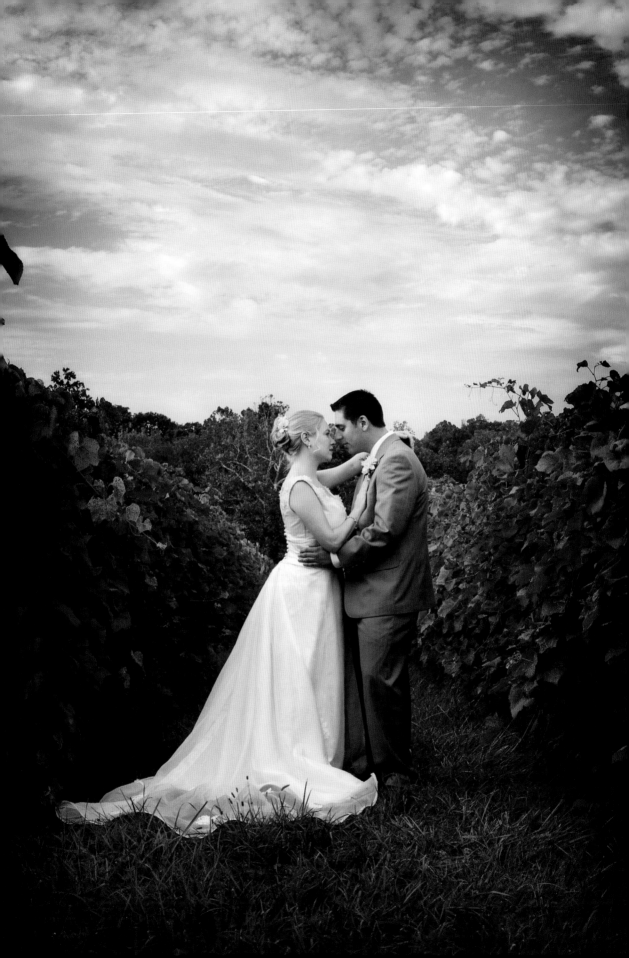

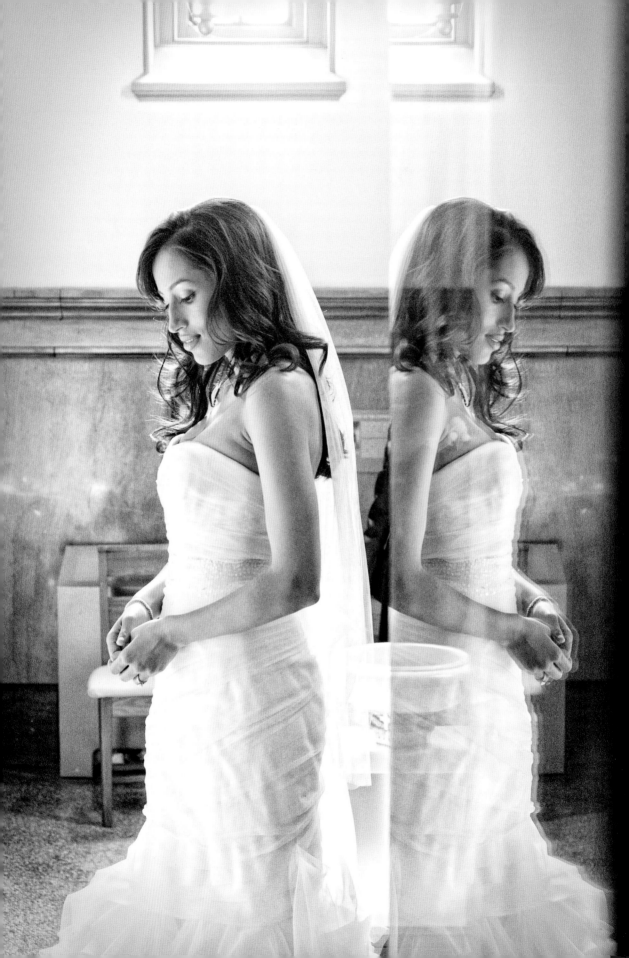

1. GETTING STARTED

Time to Make a Change

If you have been shooting weddings and feel like you have been stuck in a creative rut, doing the same things over and over, then it may be time to make a change. The same can be said if you have been working in the same client pool for a long time and are ready to step up to a higher-end wedding clientele. One of our favorite terms when it comes to wedding photographers is "clock punchers." The term applies when you have done the same thing for so long that you no longer have passion for it—you just show up, punch in, go through the motions of the day, and punch out when the wedding is over. You know you have reached that point, or are almost there, when at the end of a wedding you are constantly checking the time to see how long it will be before you get to go home.

previous page—Sometimes as photographers it is important to reflect on your business and decide if it is time to make some adjustments to your current business model.

Admittedly, at most receptions, you get to a point that you have shot every single person on the dance floor and everything is becoming repetitive. But if you truly enjoy photographing weddings, then you should enjoy the atmosphere and not only love taking photos but also enjoy the music and the spectacle of the whole thing.

If you have reached the "clock puncher" stage as a wedding photographer, have no fear. You can be saved! First, you need to address a few things in your business structure so that you can reach the next level of weddings and see new things in more lavish surroundings. Secondly, you need to find new images to create with your clients and explore new locations in which you can work with them. You'll need to find innovative ways to create images of the bride and groom and create new approaches for capturing details, fun new group shots, interesting room shots, etc. All of this will be covered in later chapters and hopefully give you a boost.

Photographers can and should get an adrenaline high from creating amazing images during the wedding day. When you reel

off amazing images and your clients and the bridal party are excited about the experience you have given them, then you will find yourself in a different emotional place at the end of the night.

It is important to make changes in your business, marketing, and shooting that will change your attitude and heighten the emotional approach to the day. Sometimes that change in attitude is far and away more important than anything else you can do to help your business.

Separation Anxiety

It seems there are wedding photographers on every corner and droves of new photographers are entering the ranks. Many established photographers feel frustrated and believe that they must fight to maintain their standing in the industry. Newcomers are excited: they are eager to learn new techniques to try to get a foothold in the business.

The truth is that people are getting married in record numbers, and there is more than enough work to go around. If photographers put the same energy into growing their business that they put into worrying about who the competition is and what they need to do to stand out, they would have great success.

The first thing you need to realize is that not every photographer who enters the industry is your competition. Consider those other studios vendors who happen to offer the same product. In the soft drink industry, two large companies offer similar-tasting

One of the barriers that tends to hold many photographers back is focusing too much on those they perceive to be their competition. Putting that energy into your own business growth versus worrying about others will always serve you well.

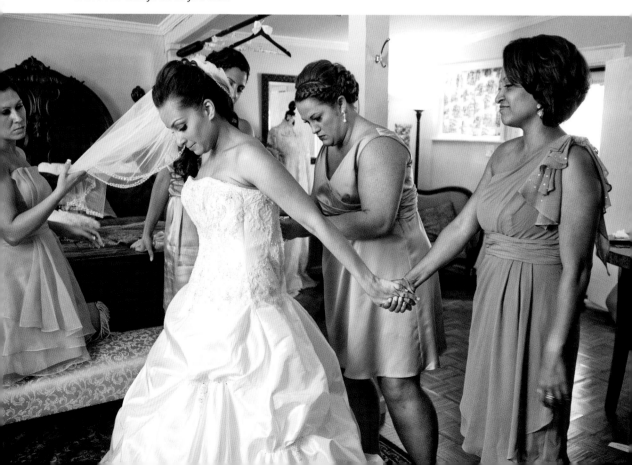

beverages but differentiate themselves in their packaging and branding and the things they do to market to their clientele. There is a lesson to be learned there.

Rather than thinking about what other photographers are doing to get their clients and basing your marketing decisions on that information, determine who your client is. If you take 100 percent of the photographers in your area marketing themselves to brides and group them together, the number can be overwhelming. However, if you break them down into groups based on style, pricing, services, and target client, you will see that the percentage of studios who are competing for the same bride drops dramatically. After all, a bride who is looking at an $8,000 photographer is probably not looking at a $1,500 photographer, and the reverse is true as well. This line of thinking should ease some of the anxiety.

Once you've broken down the sum total of photographers in your area into smaller groupings (based on pricing, style, etc.), ask yourself where you fall. Figure out what your target average wedding price is and what style of photography you plan to offer your clients. From there, make decisions about branding and marketing your services to those clients based on that information— not what other photographers are doing. If you base your decisions on other photographers' marketing efforts, you may find that you are courting the wrong clients.

Find Personal Inspiration

Whether you are just starting out in the wedding photography industry or looking to begin creating new types of shots,

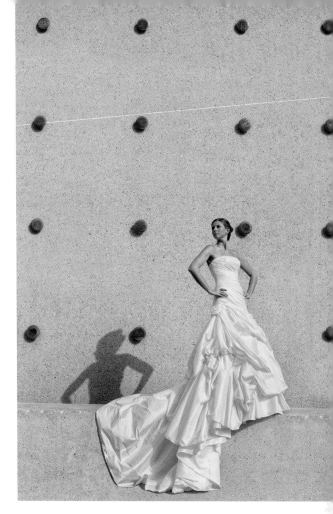

When looking for inspiration, look to the work of photographers in other states or even other countries.

nothing can be more helpful than finding great photographers around the world who inspire you to try new and innovative things.

I have two tips that I give when photographers are looking for inspiration or trying to find a creative direction for their work. One is to go to a book store and look through the books in the photography section or surf the Web to find amazing work and pinpoint trends and images that you like. Two is to stay out of your own backyard; look to photographers from

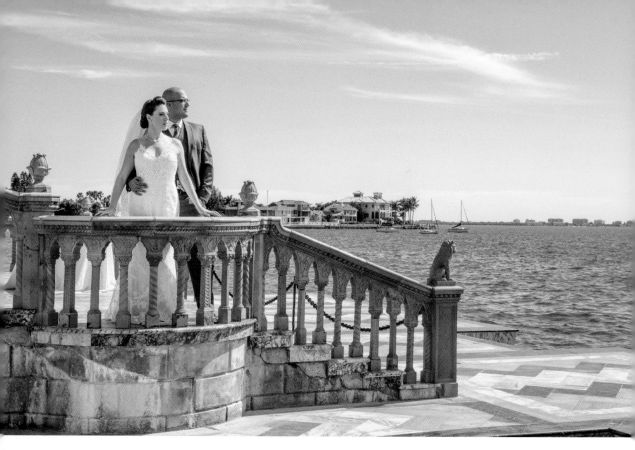

When developing your marketing strategy, it is far better to create a targeted plan to find the specific type of client you would like versus a broad plan which would likely bring you many clients who don't fit your business model.

other states or even other countries who inspire you. The last thing you want is to be accused of imitating your direct in-market competitor's work. If someone is already successfully pulling off a certain look in an area, then the best thing you can do is offer something that is different and unique that will help you stand out.

It often seems like the work that is coming out of other countries—like Australia, for instance—is innovative, different, and three or four years ahead of what we see here in the United States. By studying work in areas like this, you will find work that is fresh and different—and if you are

lucky, you will find a great photographer who tours and lectures in the United States whom you can one day study with.

Another great idea is to keep a desktop inspiration folder in which you keep images from the Web that you love. Before each wedding, go into the folder and pick an image or two that might be fun to try and would be a good fit for the event or clients you are photographing. Do not *copy* the images that you love; be influenced by them instead. Use them as a launching point for an image or style that you like and want to try, but put your own twist on them to make them yours. As an artist, your goal shouldn't

be to become a clone of someone else; to be told that your work looks just like that of some well-known photographer is really a compliment for the other photographer, as he or she is the one whose work is recognizable. Create your own style and make images that people will recognize as yours. This isn't something that happens overnight, but it is worth the time and effort.

Go Fishing

I liken marketing to fishing. There are photographers who cast a broad net into the water and are never sure what they will get. They end up with lots of responses and hopefully find a few clients who will be a good fit for them. Other photographers are more like advanced fishermen. These people have a specific fish in mind, have researched the best type of bait to get those fish, and know the absolute best place to cast their lines to get a bite.

Both types of marketing work, but one will put you in a much better position for long-term success. The net-casting method of marketing means you are spending a lot of money advertising in various magazines, doing lots of bridal shows, and holding networking meetings. With this approach, you send a general message about who you are and what services you provide. Pho-

"If you put the money into high-end materials, you will attract high-end brides who are willing to spend more for your services and products."

tographers who take this approach do not necessarily put a lot of time and money into what is presented to prospective clients. They are content with showing some prints and wedding images in albums and having a few business cards (and maybe postcards) available.

The advanced fishermen take a targeted approach. They create a carefully tailored message about their business and are willing to spend money for a larger ad in one magazine, as opposed to taking out ads in numerous smaller publications. They target specific vendors to meet with and don't wait for a networking meeting to speak with them. In fact, these photographers make an effort to schedule a lunch meeting or coffee time with that vendor because they know that vendor routinely works with the exact type of bride they want.

This photographer spends extra money on things like display albums with exquisite covers and beautiful layouts. They pay extra attention to the feel and quality of the paper that their marketing materials are printed on. They show their best images in large sizes and in great frames or special presentations. Their booths at a bridal show feature customized, higher-end furniture and decor and never use the furniture and drapes that are provided for them.

There is a saying: "You have to spend money to make money." While it may be hard to swallow, especially when you are just starting out, you have to look at these expenses as an investment. If you put the money into high-end materials, you will attract high-end brides who are willing to spend more for your services and products.

The great benefit of booking a high-end client is that they often respect you for the art that you create; you are not simply a hired servant. It's interesting to note that you'll likely give more away to convince a budget bride to book your services because so many other photographers are competing to book the same bride. You end up giving up more hours, spending more on products, and usually not getting the lavish weddings you need to lure the high-end clients whose weddings you want to book.

When you take the advanced fisherman approach, you have to book fewer weddings to make the same money you'd bring in using the net-casting approach. If you can charge more and work fewer hours at an event, you won't have to work nearly as hard to earn a living. You can book more weddings if you want and make even more money. You will have more creative energy and you'll find you are less tired at the end of the wedding season.

This is a circle-of-life kind of marketing: If you make the hard decisions when you get started and are patient, you will have a more successful business model in the long run. It's a far better option than starting out charging too little and trying to raise your prices and reach a new clientele later.

Be Confident

When it comes to working with potential and current clients, the old game "the first one to blink loses" can be your best friend. Being confident in how you communicate with a client often helps them feel more comfortable with their decision to hire you. After all, you are the expert; they are relying on you to help them achieve the wedding photography experience they want.

A lot of this confidence comes in getting used to a routine while photographing weddings; this obviously comes with time. This is why some of the best photographers in the wedding industry were second shooters for years before they started their own business. Working as a second shooter allows you the opportunity to learn from an experienced photographer and discover what works—and what doesn't. When you are working in a supporting role, you don't have to be the primary communicator with the client but can witness good or bad communication with a client so you can know what will work best for you.

If you haven't had the luxury of working as a second shooter for weddings and decide to dive right in, do your research. You will probably shoot some weddings on the cheap, as you won't have images to market your services with. Even those weddings will require you to go the extra mile. Visit prospective locations at the same time that you will be shooting on the wedding day to identify the best spots to work in and determine what the light will be like when you are there. Look at images from weddings taken in those locations to get visual cues as to what has worked in the past. Also, meet with other vendors to get a clear picture of what to expect at the event. This can prove to be quite helpful.

following page—Keep in mind that when it comes to photography, you are the expert. Be confident in the actions you take and the statements you make so that your potential clients will be more comfortable in their decision to hire you.

Putting in the time to make sure you are prepared for all of your weddings—whether it's your first or your hundredth—will make it easier to answer questions as you and the couple plan for the day. You will also spend less time wandering around aimlessly on the wedding day trying to figure out what to do. This will result in more and better images for your client and your portfolio.

You will find that if you are confident from day one in conveying your ideas and plans for the wedding images, you will meet with less resistance from the couple. Your clients will generate valuable referrals—in fact, they will likely tell their friends they'd be crazy to not hire you.

How Clients Find You

Once you've identified your target client, you'll need to develop a plan to ensure clients can find you. When we started our business, we sought to find out where other local studio owners were advertising and gaining the most exposure. For us, the cost of advertising was a major factor in our decision-making process, so any free advertising we could find was definitely worth signing up for.

The Internet was a great means of attracting clients when our business was new—and it probably always will be. In those early days, there were lots of new websites popping up everyday, and every

There are several tools you can use to help clients find your business. The Internet, print media, and bridal shows are great marketing resources, but none are more valuable than referrals.

wedding vendor was vying to become every bride's number-one choice. Many proprietors added to their own site links to other wedding vendors' sites in an effort to extend their reach. We did a search for websites that targeted the wedding market and newly engaged women. Most offered a basic free listing directing traffic to our website. We received multiple e-mail inquiries, on a daily basis, from prospective clients who wanted us to provide price quotes. We had to create a generic response to stay on top of all the inquiries. Today, there are still many web-sites that offer free basic listings. If you are operating on a tight budget, this is a great option. Some of the companies offer an upgrade for a nominal annual fee; if you can afford it, go for it. It's a small investment for a potentially large return.

When we had images to show and were ready to advertise in local magazines, we searched for only those with a high-end look and feel—ones that brides would want to use as a resource during their wedding planning. We checked to see how our competitors advertised. Like many new businesses,

we thought the largest ad would command the most attention, but in time we discovered that an ad with dynamic images will grab a reader's attention, even if it is only a quarter of a page. The key is to make your ad stand out. If you take a close look at various magazines, you'll find that most vendors have similar ads. If this is the first time brides are being introduced to your business, you must show them quickly what sets you apart.

Client referrals and great reviews are crucial in a saturated market. One bad review can cost you many future clients. Bad news travels fast, and brides will look to reviews before they invest in your services. Even when you have done your best to resolve any client issues, it's how you treat that client and how you handle the situation that will determine how a bad review will affect you in the long run. Once we had our foot in the door with the vendors we wanted to work with, we nourished those relationships like our livelihood depended on it. When we promised vendors images from an event we worked at together, we made sure we delivered. We learned from trusted vendor friends that many of our competitors were being dropped from the preferred-vendors list because they did not deliver on their promises. The moral of the story is that laziness can be deadly to your business.

Branding

Determining who we are as photographers and what we will provide to our clients is not an easy task. When we started down the path to building a wedding photography business, we knew we enjoyed photograph-

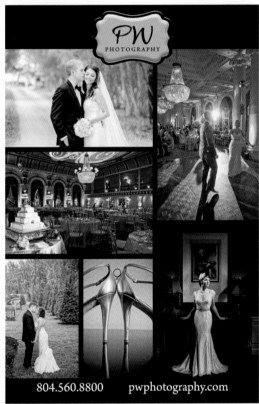

The front of our business card, blog boards, and magazine ad use the same look and layout style to ensure there is a consistant look across our marketing platform.

ing weddings, and we took our jobs very seriously. Other aspects of our business—for example, what our logo and website would look like—were up in the air. We decided to research what national and local studios were doing—and that led to some confusion

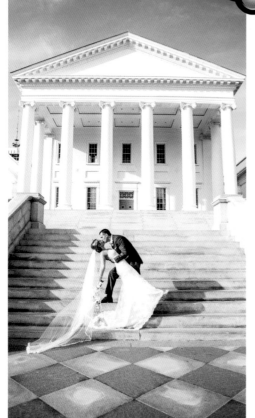

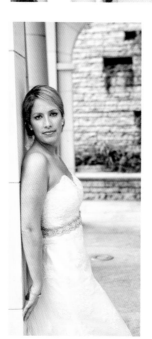

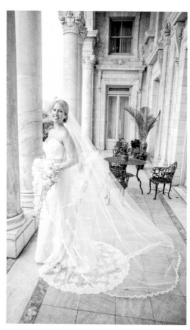

If you have limited time at networking meetings, then focus your efforts on vendors who typically are booked before the photographer for weddings. Venues and planners are always a great start.

about our identity. We were inspired by the images we saw, the sea of website designs we loved, and even the packaging others used to deliver products to clients. We excitedly embraced some of the options that spoke to us and, after investing lots of time and money, we grew tired of most six months later.

It took what felt like an eternity to finally come up with who we were. We designed a logo that reflected our simple tastes and infused elegant patterns as backgrounds on our website and packaging. The elements had an upscale look with a modern flair—a look that was suited to our imagery. Once we had this established brand, anything that our company was associated with was recog-

nized, and there was no longer a question of which studio took certain images. We had finally created our signature look, which has remained consistent for many years. Our business cards, website, social media sites, and packaging are identifiable as our own.

Networking Groups

Networking meetings allow you to meet with lots of different vendors in your local wedding community and potentially form relationships with people who can refer brides to you.

Seek out established wedding vendors and ask them if there is a local bridal association that hosts meetings. Local wedding

publications may host meetings as well. Many groups have websites or social network pages that may list upcoming meeting dates and locations. Some meetings may feature speakers or offer an educational component.

When you attend a meeting, carry lots of business cards and maybe some postcards so that you can share your work with the vendors you meet. Wedding planners and ceremony/reception venue owners are your strongest allies at these meetings, as their services are typically booked before the couple hires a photographer. This means they are in a great position to refer clients to you. Bakers, caterers, dress and tux shops, invitation companies, etc., are great resources for you, but they typically don't meet a bride and groom until after the photographer is booked. Having a strong working relationship with them can be helpful, though, as they may on rare occasions meet clients who haven't found a photographer yet. Also, if they own storefront locations, they may allow you to display your work.

If there is no networking group in your area, you can create one of your own. Find a great reception venue and approach the owner about hosting a wedding vendor network meeting at the facility. When you have a willing host, ask them to invite other local

"When you attend a meeting, carry lots of business cards and maybe some postcards so that you can share your work with the vendors you meet. "

vendors on a specific night and have cocktails or coffee. Make it a simple meet and greet. Encourage everyone to bring business cards to exchange. While meeting, connect with vendors with whom you might partner; they can become a long-term referral source. Also, keep your eyes open for a vendor who is willing to host a meeting the following month.

As your business grows and you begin to book higher-end weddings, you will already know many local vendors from the network meetings. You will also have had an opportunity to learn about others' business and marketing models and how they interact with vendors and potential clients.

Studying the business habits of successful vendors can be key to your growth and development. Learn from them; observe them at network meetings and note how they interact with people. Doing so will help you to mirror their success. Vendors often like to work with other vendors who remind them of themselves. Embrace their habits, and you may attract the type of vendors you want to work with and, ultimately, the type of clients you would like to book.

Pamper Your Vendors

Coming up with different ideas to pamper your clients can seem like a pain, but your clients aren't the only ones who need special care and attention. The vendors who work on the same weddings with you also impact your reputation. Due to the nature of the services they provide, some vendors will meet with clients who have not yet booked a photographer. Being on their preferred-vendors list is important. When you first

start your wedding photography business, you may not know any wedding vendors. Establishing a connection with a few will start the ball rolling in the right direction. To accomplish this, attend networking meetings or invite vendors to meet with you. When you work with a vendor at a wedding, provide them with images they can use to promote their business. We created a list of top venues and people we hoped to work with. Once we had a foot in the door, we invested time to ensure their needs were met. We initially offered to design and create business cards for some vendors; for others, we took executive portraits for their websites and marketing materials—for *free*. When they refer clients to us, whether they

book with us or not, we let them know we appreciate the referral.

During the holidays, we like to play Santa and hand-deliver gift baskets and presents to our favorite vendors and those we hope to work with more in the future. This is one of the most fun things we get to do. We love their surprised faces and warm welcomes. We often receive gifts from other vendors whom we have worked with. These gestures tell us that they appreciate what we have done for them. Their thoughtfulness makes us want to recommend them more often. Leaving a positive and lasting impression is important; it can really increase your referrals. Remember, laziness can kill your business. There will always be another pho-

Investing in things like branded marketing cards for vendors you like to work with can be a small investment for the potential referrals they can send your way.

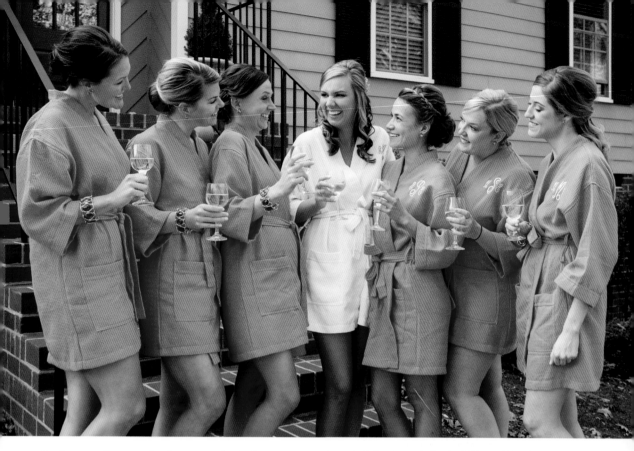

Finding creative ways to show your clients that you appreciate their business helps build brand loyalty and and will give them one more reason to send their friends your way.

tographer who is ready and willing to take your place on the preferred-vendors list.

Pamper Your Clients

Once you have landed some great clients, you need to show them why choosing you was the right decision! You often hear that you should treat others as you would like to be treated. This is accurate, especially when it comes to clients who just signed a contract with you and will not see any of the things they purchased for quite a while—sometimes not until the wedding day.

From the beginning, we want our clients to feel welcome and pampered. We want them to know that we are there to help

them in any way we can. We express that they can reach out to us for help, advice, or any recommendations—even if it's not photography related. We want to have a hand in some of the decisions they make so we can guide them in creating the best-possible event, which may increase the chances that images from the wedding are published. Creating press-worthy images is your responsibility. Anything you can do to make that happen is worthwhile for you and your client!

During consultation meetings, we provide clients with beverages and treats. We invested in a one-cup coffee maker and created an elegant menu with a variety of coffee and tea flavors—and we always have chocolates

available. We also invested in a great set of coffee and tea cups that reflect the elegance of our studio and fit our brand. Pampering our clients creates a positive connection. Hospitality goes a long way to making others feel welcome. We want to convey the message that we know their time is valuable and taking time to meet with us is worth it.

The way we have pampered our clients has evolved over the years based on what was popular in the wedding industry. For a long time we surprised couples with custom baskets that they would find in their limousine after the reception or in their suite on their wedding night. During our many conversations, we would ask questions to get to know them and their interests and try to add a personal element to their basket. We purchased large quantities of candles, bottles of wine, wine glasses, chocolates, and anything that would be enjoyed. We even added a small picture frame with a little note where the image would be letting them know that they could choose their favorite wedding image as their gift. The baskets were such a hit with clients and wedding planners that future clients began to expect their own baskets early. Once this happened, we knew it was time to do something different. After we stopped gifting baskets, we actually had a bride contact us because she didn't see a basket after her wedding. That instance, though frustrating, proves that word of mouth travels fast, and the way that you take care of your client is of utmost importance. No matter how you choose to pamper your clients, make sure that you choose items that are relevant to that particular couple. Remember that you don't have to break the bank to impress your client. A nice gesture can go a long way.

Stylized Shoots

A great way to add to your portfolio and show the types of weddings you want to book is to team up with wedding vendors to create a stylized shoot. It is much easier to book a certain type of bride or wedding if you can show those clients that you have shot the type of images they are looking for. Many magazines and national blogs now look specifically for stylized shoot submissions and even hold contests to get the best-possible images to show.

The benefit of stylized shoots for both you and publications is that you have plenty of time to make sure you capture every detail in the best-possible way. You aren't limited to the details that a wedding client may have at their wedding; it is the vendors' opportunity to try and show new things. You can photograph new scenes and capture images that allow the vendors to strut their stuff to potential clients.

If you want to do a stylized shoot, your first step will be to decide on the style and look you want to create. Next, you will need to assemble a team of vendors to create this look. Find a gown and tux shop to outfit your models; a great location that fits the look you are going for; a florist; a hair and makeup artist; a wedding planner/designer; a furniture rental business; a prop rental source; a linen, crystal, and flatware rental company; and a printing company for menus and invitations, etc.

Once you assemble the team and begin to discuss your vision, the group will work

Stylized shoots are a great way to share an experience with multiple vendors to create images for your portfolio or to help you create marketing pieces that can help vendors you like working with and enure that it's your images they are sharing.

together to come up with ideas that will make the shoot look amazing. Often, members of the team may have ideas you have not considered and relationships with vendors you are not connected with who can bring something extra to the shoot.

Your biggest job outside of the shoot itself will be working with all of the vendors to coordinate and make sure that everything comes together perfectly. On the day of the shoot, take your time and get lots of great images. When the shoot is over, provide finished images to each of the vendors involved in the shoot so they can use them in their marketing. We always provide these photos with our studio watermark so that when they are used on the Web, all of the vendor's potential clients can see that we took the photos and might contact us to photograph their wedding.

Stylized shoots present a great opportunity to network with vendors before and during the shoot. This can result in referrals. You also end up with great images that you can use on your website and show off at bridal shows to draw clients. Those same images will be shown all over the involved vendors' websites and social media and will help promote your business. Of course, you will also have a great set of images to submit for possible publication for added publicity. Stylized shoots may not generate income for you directly, but they can lead to great visibility and the potential for lots of clients.

2. BRIDAL SHOWS

The phrase "For better or worse" is typically used during the recitation of the wedding vows, but many vendors feel that it also applies to attending bridal shows to market their business to prospective clients. There are two undeniable truths: If bridal shows are done right, they can help you fill your calendar. They also are a lot of work and result in a long day of standing, meeting brides, and seemingly talking nonstop.

The great thing about bridal shows is that they are typically run by companies that advertise on television, the radio, and the Internet, as well as in local papers, to grab the attention of brides-and-grooms to be. For you, this is an ideal scenario. If you make the right design and display decisions and position yourself well, you can have great success. Yes, there will be other photographers at the bridal show, but as mentioned earlier, you are not competing with every

previous page—Much like a bride on her wedding day, you want to make sure that your business looks its absolute best at a bridal show.

photographer there—you are only competing with the photographers who have a similar style and price point. It is a good idea to put all of your effort and energy into making sure you represent your business to the best of your abilities rather than trying to compete.

In this chapter, you'll learn tips for making sure that your bridal show experience is a success. We'll teach you how to draw brides into your booth and make sure that, once they are there, they feel it would be a mistake to book anyone else.

Location, Location, Location

When you sign up for a bridal show, the first thing you should do is find out what spots are available. You want to reserve a spot in an area with the best traffic flow. Organizers will provide you with a copy of the floor plan and let you know what spots are available. Be sure to ask the individual whom you meet with to tell you which area of the show gets the best traffic and where you would do well to place your booth. We like to choose an endcap or corner booth and skip the rails. This way, we end up with a space that feels larger. For example, if

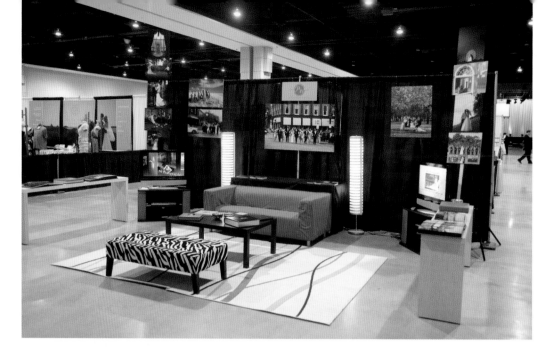

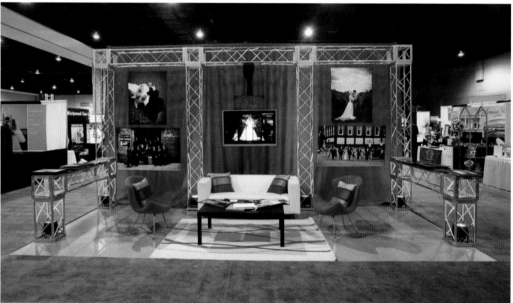

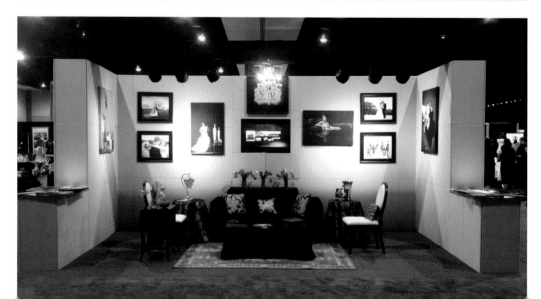

you were to book a 10x10-foot booth in the middle of an aisle, you would have 10 feet of booth entry space; in a corner space, you would have 10 feet on the side and 10 feet in the front for a whopping 20 feet of booth-entry space.

The next thing to consider is where within the show you want to have your booth. If you are at a show that has one main entrance, then being able to get the first space a bride sees when she walks in and the last one she sees when she leaves will allow you to create impact and will make a lasting impression. Of course, such a space is usually the first to be reserved—and they rarely become available. Also, spots like that often come with a bigger price tag, but they can be a good investment.

If there are no front booths available, check to see if there will be a fashion show or event that will cause brides to congregate in one area, then try to rent a space on the outskirts of that area. Some brides will spend time in your booth while the show is happening so they can feel like they are able to see the show and gather information at the same time. On the other hand, having a booth away from the fashion show has its benefits, as some brides know they can more easily browse while other attendees are busy taking in a performance. In this case, a booth far from the music and cheers can be a good draw.

Another place where attendees often congregate is the registration booth. Some bridal shows will have the registration inside the show off to one side immediately upon entry. Being across from the registration booth gives your booth plenty of facetime with brides as they wait in line for their turn to register to enter the show. The more time you can get a bride to look at your booth, the more time they have to potentially fall in love with something you have done and want to come speak with you about your work.

Finally, people tend to congregate by concession stands. If brides come during lunch and grab a quick bite, they will often sit at a table to eat. While they eat, they will take in their surroundings. If your booth is facing the concession area, they can get a look at your work.

Bridal show organizers tend to make every effort to give similar vendors as much distance from one another as possible. If there are many vendors of a particular type, however, they may be forced to put competing vendors in close proximity to one another. Always request that you are not directly connected on either side to another photographer. Getting an endcap or a corner booth can reduce or eliminate that possibility.

Getting Ready for the Big Day

Once you have chosen your location and know the size of your booth, you can start thinking about what your booth will look like. Consider the color palette you want to employ, determine what kind of furniture you want to use, and decide whether you want to use the pipe and drape that is

Having an idea of the layout and flow of a bridal show before selecting your location can be very helpful. Also, be sure to rely on the experience and guidance of the show director. It can be invaluable.

provided—or something else. Avoid grabbing lots of albums, pictures, and cards and throwing them on a table and on easels. Make sure the frames match and that you don't use clashing tablecloths on the tables.

Your goal is to create an environment that brides will want to visit. Think about the form and function of your booth. For example, an area rug adds not only ambiance but a soft place for attendees to rest their feet, especially if the show is at a convention center that has a concrete floor. Renting or borrowing tables, chairs, and linens from other vendors who are at the show can give you a design advantage over photographers who use what is provided by the show organizers. In fact, vendors will often let you use rental items for free so that their goods are on display in numerous locations around the show. Some might even send brides to your booth to see a certain linen or table type; this means they are also sending you a prospective client.

We have had great success with vendor relations at bridal shows. We have been able to design booths with truss work and uplighting with colorful drapes, usually for little or no rental fee. This gives us the freedom to think outside of the box and show our appreciation for some of the great vendors whom we work weddings with.

One of the smartest things you can do is lay out your booth in advance—especially if you are planning for your first bridal show. Once you have decided on the size of your booth, tape off an area of your floor that is the same size and put all of your booth items in place to make sure they all fit and look pleasing. Doing this will allow you to see whether you will have any issues to iron out well in advance of the show. You'll also want to figure out how many power cords you will need and how long they should be.

Put Your Best Foot Forward

You've set up your booth and you are confident it's going to be a hot spot for traffic on the big day. Now what? We've learned that it's wise to take a look at every inch of the booth with a magnifying glass to be sure you aren't missing anything that may pose a disaster. You get one chance to impress

potential clients, so take the time to do it right. Start with the walls. Make sure your sign is in the appropriate location so it's visible from all angles. Confirm that all portraits on display are securely hung and match your general decor. Place any tables you plan on using toward the sides and back of your booth so brides are able to enter your booth and view your products. If you place your tables in front of the booth and stand behind them, you will make it difficult for prospective clients to enter your booth and they will simply walk by. On the display tables, less is more. Do not crowd the tables with so many albums and materials that one can't open an album completely to see the entire spread. Your goal is to draw the attendees' attention so they will enter your booth to see what else you have to offer.

We recommend having a small vacuumed rug in your booth, taped down or with a sticky pad underneath to keep it from moving. Your feet will thank you at the end of a long day. We've found that many brides come by our booth at the end of the show to relieve their tired feet on our soft, cushy rug—it's the perfect opportunity to chat with them before they leave and ensure that they will remember us.

All linens you use should be ironed and straight. Keep the patterns simple so they do not compete with everything else in your booth. If you have any lamps or anything else with a cord, be sure the cords are tucked away. Visible cords are an eyesore and can be a safety hazard. If you are able to invest in promotional materials such as pens, magnets, or any other small item with your company logo and information, only

Much like a bride in the weeks before her wedding, you want to make sure you have planned everything out in advance so that there are no surprises on the day of the bridal show.

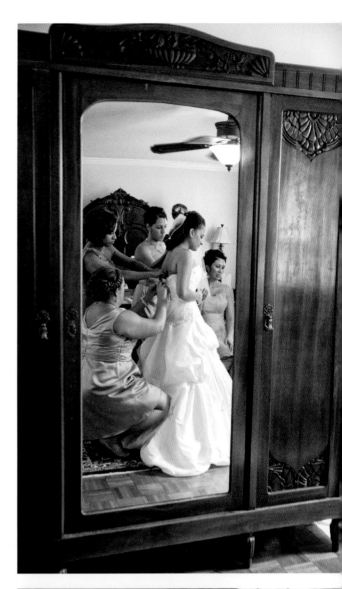

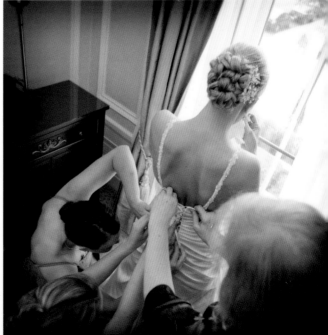

give them to those who sign up to receive additional information. You do not want to waste your time and money on a herd of people who enter your booth only to receive their free token. This goes for having candy at your booth as well—if it's free for all to enjoy, expect that there will be people who only stop by long enough to grab what they want and leave. We recommend creating postcards or marketing pieces that visitors will take. Make sure they are consistent with your brand and website. When the brides leave the show and start to research all the vendors they visited at the show, you want them to remember you above the others.

You've covered all your bases and now it's time to look in the mirror. You are the one selling your business, and you are the artist. The way you present yourself is just as important as your product. You may consider yourself a casual person in your everyday life, but you need to reflect on what it is your business stands for. We command a high price for our services, so we dress and act professionally when we are in front of prospective clients. If we expect a client to invest a small fortune for our services, we want to look and play the part. If your business and personality are both casual, then

market yourself as such, but don't expect a client to hire you if you are the opposite of what they are looking for in a wedding photographer. In the real world, how you dress and the way your business looks matter—especially when it comes to high-cost services.

Go Big or Go Home

Once the show starts and you have traffic by your booth, you will have mere seconds to grab an attendee's attention. One of the biggest mistakes commonly made by photographers is to use small images in their booth and emphasize quantity over quality. The reality is, no matter how good your images are, if a potential client doesn't step foot into your booth, she will never see how talented you are.

Think big. Pick out a handful of your most impactful images, preferably ones that are different than those most photographers show. Print them large—20x24 inches, 20x30 inches, or bigger. In many of our booths, we made sure that our prints all had one side that was at least 48 inches so that they could be easily seen as brides walked by.

If you have those great large images, even just three or four of them, hanging at eye level or higher, they will draw clients into

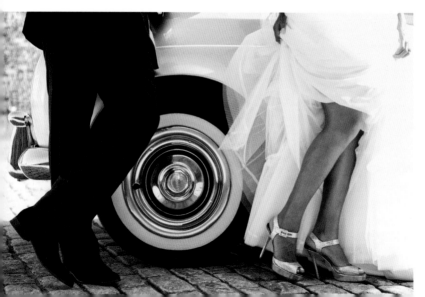

left—Take the time to go over every inch of your booth and make sure that even the smallest details do not become a problem or distraction. *following page*—You only have a few seconds to catch the eye of potential clients. Showing a few large photos with impact is more likely to grab their attention than displaying several harder-to-see images.

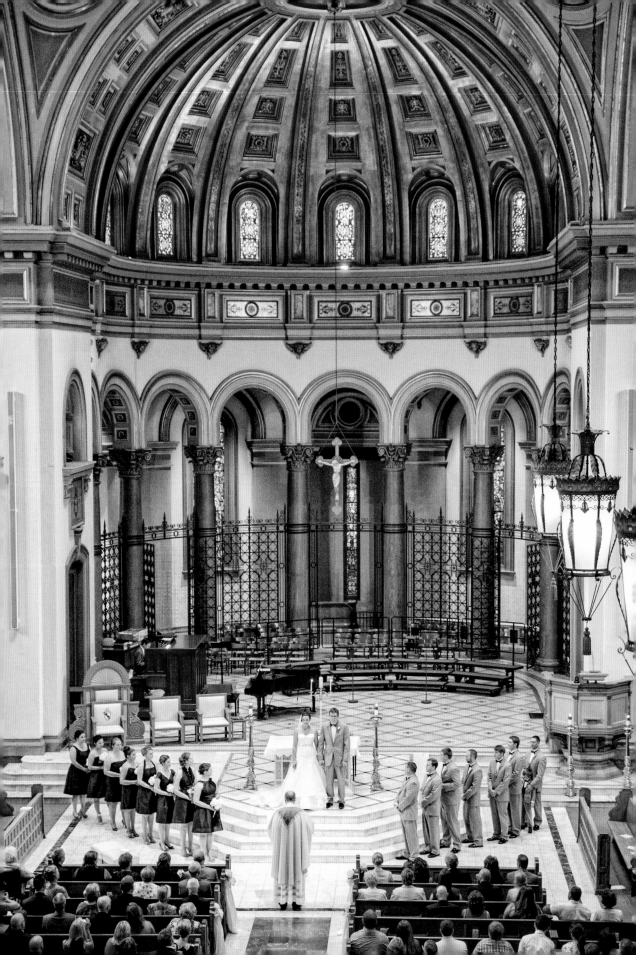

your booth and they will have an opportunity to see all of the other great photographs you have displayed in albums or in other presentations.

Another thing to consider is the height of your booth. Just because the pipe and drape is set up at only 8 feet doesn't mean that you have to keep everything at that height. Check with the show organizer and make sure there are no rules regarding booth height. Once you get the thumbs up, the sky is the limit. We routinely brought in our own pipe and drape that was 12 feet high, and we mounted prints near the top of it. We also mounted large prints on light stands that were 14 feet high. The benefit of this is that your booth can be seen from anywhere on the show floor. If your booth is taller and larger than the others in the show, you will get extra attention.

If you are going to play a slide show, go big. Images shown on a small screen may not be noticed. Consider renting a big-screen TV and maybe a TV stand that holds it at eye level. You could consider using a projector for very large images, but you have to consider the footprint the projector needs so that people are not blocking the projected image. You may need to opt for a rear-projection setup, which could mean you'll need a larger booth or will have to stage the projector high enough so that it does not interrupt traffic within your booth or cause the images to appear obstructed.

Remember that your goal is to grab the attention of brides-to-be. Use the impact of your images and your booth to full advantage. Let them serve as a magnet to draw clients into your space so that you have an opportunity to speak with them and let them know how great you would be to work with.

The Right Tools for the Job

When you start packing for the show, you are going to need tools and items to help with your setup. The general rule is bring everything you may possibly need and

Bring more tools than you think you will need for your booth setup; it's the one you leave behind that you will most likely need. Plus, you never know when your extra tools will be needed by a neighboring vendor and your payback will be a great referral.

more. The last thing you want is to be in the middle of your setup and run into a problem that you're unprepared to handle.

Bring your entire tool box with all of the standard components in there: pliers, screwdrivers, hammers, etc. Also include a staple gun, several different types of tape (packing, scotch, masking, double-sided carpet, duct), a step ladder, a hand truck or cart, nails and screws, wire that can be bent and used to hang things, and extension cords. The list of tools is extensive but can be a saving grace when you are setting up your booth. Consider investing in a sturdy tool box that will hold your body weight so you can step on it to get an extra 12 inches or so of reach. This can be helpful for setup, too.

Large plastic Sterilite totes are also great to have on hand. We load albums, cards, linens, and more into clear totes so that we can easily carry them into the show for setup and can see at a glance what each holds. We use a hand truck that doubles as a flatbed cart and a step ladder. We can load the totes onto it and roll them all in with just one trip. We can also use the hand truck as a ladder when we are setting up the booth.

Taking the time to assemble all of the tools you will need for the show is time well spent and will make for a much less stressful bridal show experience. An easy and smooth setup can affect your level of relaxation and will improve the way you project yourself to potential clients for the rest of the day.

If you have done your homework and know exactly what goes into setting up your booth, then it should come together quickly and smoothly. Don't set up late; rather, arrive early and get it all done first thing. By

"An offer to help is a great ice breaker for a new vendor whom you haven't yet met and would like to have the opportunity to work with."

doing so, you give yourself the opportunity to do some powerful marketing. Take the time to walk around the show and visit with vendors who are setting their booths up. Let them know that you have tons of great tools, they are welcome to use them, and you would be glad to help if they need any assistance. This gesture may be a life saver to some vendors, but even those who don't need help will remember your offer—and they may remember you when they have a client who needs photography services. An offer to help is also a great ice breaker for a new vendor whom you haven't yet met and would like to have the opportunity to work with. Because of our outreach over the years, our booth has become a hot spot. Vendors know they can stop by to borrow something they need.

Be Different

Too many photographers display very ordinary images at bridal shows—shots that are similar to those on display at every other booth. Your goal for the show is to stand out. Find images with impact—whether its a trash-the-dress type image, a fun group shot, or a great emotional black & white image. Choose photographs that feel different and grab people's attention after they have walked by a bunch of booths decorated with

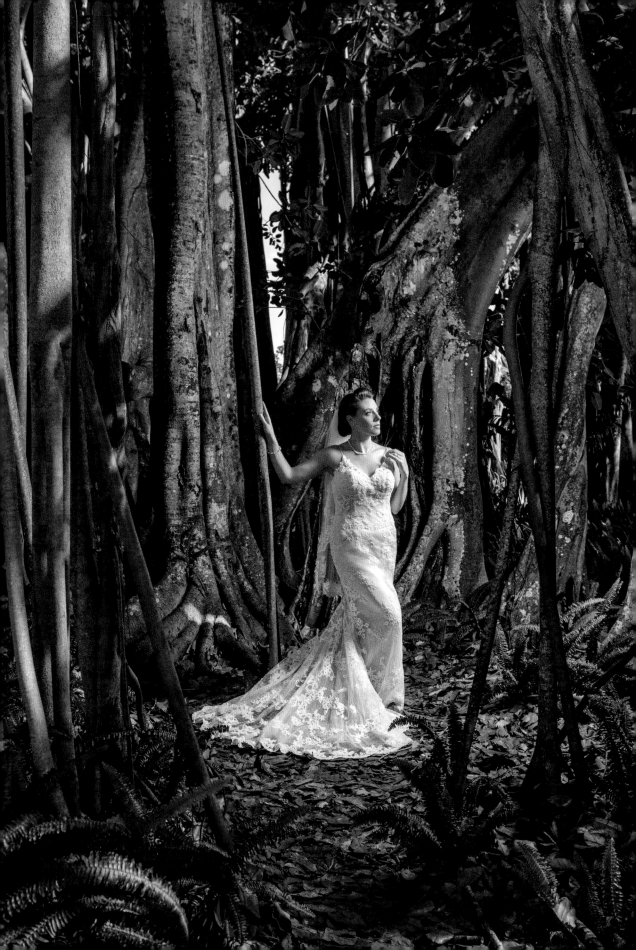

studio bridal portraits or images of a couple kissing under a veil. Look at it this way: if it is an image you have seen a thousand times, then the brides probably have, too.

Another common mistake is using the sign that the bridal show provides for your booth. It is typically a 6- to 10-inch-tall strip of thick paper stock, about 3 feet long, with your business name printed in black block letters. Every vendor is provided with the same sign and many use it. Toss the sign out and use a custom sign instead. You don't have to go to a sign shop and have something made out of vinyl that rolls up. In fact, such signs never hang straight and aren't always easy to read. We are photographers; we have access to large-size prints and gallery wraps. Create a custom sign that shows well and is easy to hang. A simple thing like this will give your booth a refined look.

As mentioned earlier, avoid using the furniture supplied by the show—bring your own. Move your tables away from the front of your booth; place them to the sides or in the back so that prospective clients can come into your booth and speak with you. Giving them the ability to step into your booth and look at your albums and images means they will stay longer.

Design and Placement

The albums you display in your booth need to showcase your best images, the work that best represents you as a photographer. This

previous page—Display images that stand out and look different from those that other vendors typically show. Photographs that help you stand out make it easier for brides to remember you.

is your chance to make a lasting impression, so don't miss the opportunity to wow visitors with your creative and unique products. Although many brides choose classic albums to showcase their images, many have no idea how many unique albums are available. As the professional, you can educate them on the vast array of album options tailor made to suit each client's personality. Pros have access to albums that the general public does not, so invest in some nontraditional albums to get attendees curious enough to enter your booth. Most brides do not want a wooden album or one made with ostrich leather, but it is interesting to see and touch something so unique. Many professional album companies allow you to create a sample album at a nice discount, so take advantage of the perk to create something eye-catching. You can offer these custom albums to your brides as an upgrade option or possibly as a nice incentive for those who invest in your largest wedding package.

Instead of leaving all of your display albums closed, consider opening some to a particular page or spread that captures the attention of passers-by. Some of the large display portraits in our booth come from weddings we really love, either because the couple was really great looking and photographed well or the location was unique. When we display a really great portrait, we try to create a sample album from that particular wedding. That allows the brides-to-be to view the wedding, start to finish, in an album. We photographed a handsome couple who had an exotic wedding in Mexico, and we like to display their images. Many visitors stop by our booth because

they want to see more images from that wedding. They are curious about the location and want a closer look. If an album has a really unique landscape spread, open it to that spread to grab the attention of attendees as the walk by. We have an album from a ballroom wedding in which blue lighting was used for the reception. The room is so different from the average golden ballroom that you can't miss the image when you walk by the album displaying it.

You might also consider displaying bridal and engagement albums. In either case, you can showcase one session, held at multiple locations, or you can present several of your favorite sessions together. The advantage of showing an engagement and bridal album is that you can offer those services to your clients and plant the seed that they can invest in beautiful albums—not just loose prints—

from their special session. If you price and market these albums correctly, they can greatly boost your income.

The Internet is instrumental in helping brides to plan unique weddings. With that in mind, we decided to create inspiration albums to help brides choose venues, colors, and details to personalize their event. We choose our favorite wedding images each year and create single-page storyboards showcasing the unique elements. We compile the story boards, print them, and present them in self-stick albums so brides-to-be can browse for ideas. These inspiration albums have been a great source of conversation wherever we take them, allowing us to tell stories about each event shown and what made them different. The albums quickly show how we capture each couple's day in our own photographic style and lets

below—Opening your display albums to the spread that shows an image on your display wall allows brides to see more of what it was that drew them into your booth. *following page*—The design and placement of your booth should be as meticulous and well thought out as that of the reception of the type of client you want to attract.

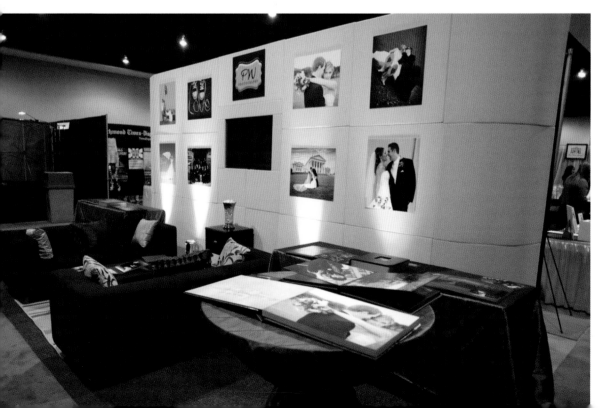

When you are talking to your brides, you want to appear in demand. Create a sense of urgency to book you before someone else does.

those who visit our booth know that we remember our clients well!

Look Busy

Once you are drawing brides into your booth to discuss your services, you want to appear in demand. Don't give prospective clients the idea that you are desperate for their booking, as you may seem inexperienced. We have always made it a habit to use language that sends the impression that we are experienced and popular.

Whenever we are asked whether we are available on a given date, we say "I think we may be booked, but let me check real quick." We then pull out a slip of paper that we have folded in our pocket with several dates written on it. This slip of paper contains a list of wedding dates that we have already booked and those dates that we don't want to work a wedding (e.g., our children's birthdays, holidays, and important family events). When we say "You know what? I am busy the week before and after you, but I am actually available for your date." We might also say, "Wow! Your wedding date seems to be very popular. We have had several brides stop by asking about that date." Saying things like this creates a sense of urgency and makes them feel that other brides have already spoken with you about the same date.

The reality is, you may have no weddings on the calendar at all, but your prospective clients don't need to know that. If they feel like you are available and no one else is in line to book your services, then they don't have to schedule an appointment to meet with you right away and you may get pushed back on the list behind other photographers they are considering. You always want to try to be first to get the meeting with the bride, as you want to set the standard by which all others are being considered and hopefully get the bride and groom to book your services before ever meeting with anyone else.

Qualifying Leads

There's a great positive feeling you get when you are faced with many potential clients who are inquiring about your availability for their wedding date. Now, if there was only a way to ensure a 100 percent booking success rate! While nothing is for certain when you meet potential clients, you can weed out the ones who will not book you by simply qualifying your leads.

After years of doing bridal shows and repeating the same information, you learn to recognize those who are truly interested in your services. You can start by greeting attendees, telling them how your studio is unique, or talking about the style of service you offer. Next, briefly mention the particular price at which your wonderful services start—a price you have determined works for you. Brides who are comfortable with your starting price will inquire further and want to hear more about your wedding coverage and what else may be included. The conversation will flow naturally. If you are well over the prospective client's budget, she may end the conversation quickly or tell you "Thanks! I will contact you." Asking

Asking the right questions and giving the right details about your services will help ensure that the person you are speaking with is the right client for you.

Bride's Name :_____

Groom's Name :_____

Address :_____

Phone :_____

Best time to call : _____

E-mail :_____

Wedding date :_____

Ceremony location :_____

Reception location:_____

__ Please contact me to schedule a consultation

__ Please mail me information regarding your
Services

I am interested in:

__ Bridal Portraits

__ Engagement Portraits

__ Wedding Photography

Instead of giving all of your package information away at the show, use the show to gather information, then send your prospective clients more information when the show has ended.

Gather Information

When you have a potential client ready to fill out your inquiry card, ask as many pertinent questions as possible. You'll want to ask for information that helps you to remember *this* individual, amidst the hundreds of others you have talked with. Ensure your form is short and thorough. The bride-to-be should not feel as if she is completing a lengthy contract. You will need the names of the bride and groom, their wedding date, the ceremony and reception venues, their contact information, e-mail addresses, what information they are looking for, and anything else you feel you will need to know for the future.

When the inquiry card is completed, immediately write on the back a personal note to help you remember the couple. If you had time to chat and discuss some of the wedding details, you should have something personal to note. When a couple is having their wedding at a venue we prefer to work at, we note this so we can send them links to our published images captured at that location. If it's a location that we have never worked at, then we are sure to visit the venue's website to gather information so we can discuss it in detail with the couple. Never having been to a bride's venue and not knowing anything about it can make the bride doubt your ability to photograph there, which may decrease your chances of booking her wedding. This is especially true

visitors to complete your client information card so you can send them information will also give them a chance to decline. Generally speaking, since we can't read minds, we still ask them if they would like to receive additional information. Most will say yes, even if they already know they can't afford to hire us. Some people just want to be polite and move on with their day. You may not be able to pre-qualify all the booth visitors, but you can certainly try to make it easier on yourself later when you contact the really viable leads.

This brings us back to how your booth looks to the public. Have you created a booth that reflects your pricing range? If your target clients are those with big wedding budgets, you will attract them by ensuring that your booth is elegant and organized. Those who get the impression that you are not in their budget will likely pass by.

if you are trying to establish a new wedding photography business and you haven't worked at most of the popular local venues. If this is the case, your confidence level when speaking with potential clients will impact how they perceive you. You can give them the impression that their venue is simply a new place you will enjoy seeing with fresh eyes and photographing in a creative way.

Before a prospective client leaves your booth, take a few seconds to ensure you can read all the information and nothing is omitted. Otherwise, you may simply take the card and add your notes so you can quickly tend to the next couple, only to realize later on that the e-mail address is missing or illegible—and you may lose a booking opportunity. The excitement of sending out mass e-mail messages with the hope of many bookings is quickly squashed when more than half are returned to you as "undeliverable" because the e-mail address is incorrect.

Clear Your Calendar

A really great bridal show takes time, preparation, financial investment, and a lot of physical energy! We can't recall a show that didn't leave us with throbbing, achy feet and the dread of having to break everything down and pack up despite the fact that we were dead tired. However, the joy of having a large stack of completed information cards from interested brides is the best reward. You need only book a couple of weddings to make your investment in the show worthwhile. Any other bookings are a profit—a fact that can boost your enthusiasm when

After a bridal show, you are hopefully going to have lots of new brides who are excited to meet with you. Be sure you have some time reserved on your calendar to meet with them.

you need it most. Remember, the show is there to get you clients and, more importantly, get your business name out there to be recognized by vendors you will likely work with in the future.

It's important to take action just *hours* after a show to ensure you are remembered. Most shows we participate in are on Sundays. Waiting until Monday to follow up with prospective clients is too late. On a typical Monday, everyone is back to work and busy with their everyday lives. Brides don't have time to look over the hundreds of cards and brochures they received at the show. This is why, the night of the show, when all the other vendors are returning their supplies to their warehouses or relaxing, you need to get moving. Be proactive: Well before the show, prepare an e-mail message you will send to all the brides-to-be. The message should clearly state who you are, how excited you are that they stopped by to visit your booth, and that you are providing them with the information that they requested. Explain how they can contact you should they have any questions, and let them know you are available to meet. A great way to remind them who you are is to attach a photo of your booth at the show (preferably a photo taken when there wasn't anyone at the booth, maybe right before the show doors were opened). This photo may also remind them of the products they

"You want them to meet with you first, so they can fall in love with you and your services before they visit any of your competitors."

loved in your booth. In the e-mail message, state some general information about your pricing—just enough to filter out those who cannot afford your services while enticing others to contact you for more information.

We have found that sending this preliminary message the night of the show is quite effective, as some brides like to go over everything in the show bags at night to relive the excitement of the day and dream about their upcoming wedding. Many brides immediately reply to the e-mail message asking to set up a meeting to discuss their wedding. Since you will have already cleared your calendar for the week after the show, you will be available to accommodate their schedule. The sooner you can schedule a meeting, the better. You want them to meet with you first so they can fall in love with you and your services before they visit any of your competitors. When a bride really loves a vendor, it is difficult for another to sway her decision, as she has likely envisioned spending her day with someone else.

previous page—A great way to remind a couple of who you are is to include a photo of your booth in your introductory e-mail. You want to be crystal-clear about who is sending them information.

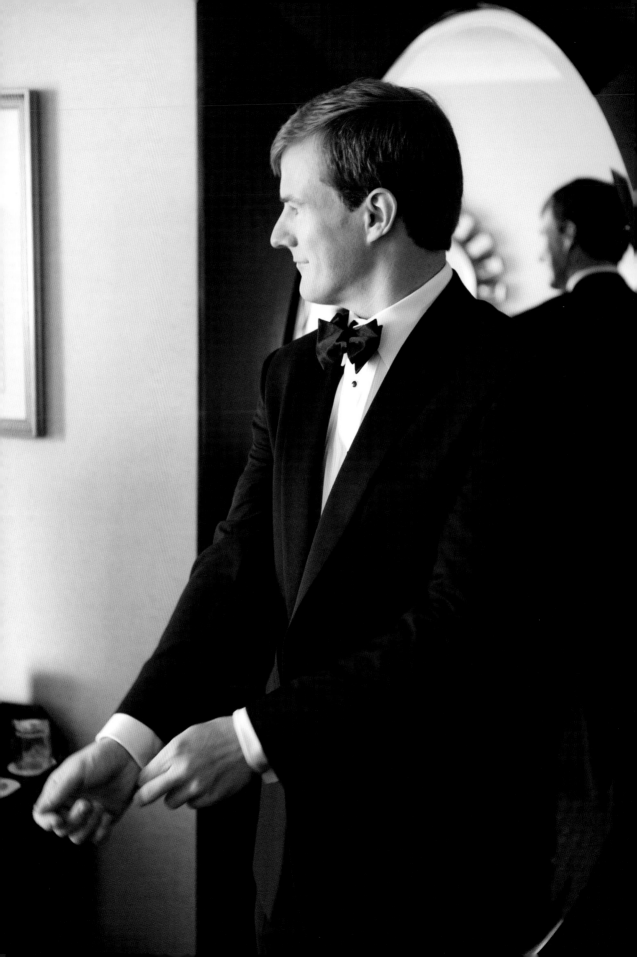

3. PRE-WEDDING REQUIREMENTS

Sell Yourself

Once you have finished the bridal show and are starting to meet with brides, it is time to set yourself apart. If you displayed the right images and said the right things at the show, then you have already started this process.

You need to look for items of distinction. You will also want to emphasize things you do that are unique to your studio. Also, try to find a way to make even the "everyday" practices seem special. For example, we shoot every wedding as a team. It is not

previous page—Just like the groom on the wedding day, you want to dress up your presentation and show your client why they should hire you. *below*—Focus on the things that you do as a photographer that are unique to you when you speak with your clients. If you are doing some things that the competition also does, find a way to talk them up that makes them sound different and special.

"People like to work with people who remind them of themselves."

uncommon for a bride to hear that she will have a photographer and a second shooter or assistant to cover their event. We make it a point to say that *our* clients get two first shooters. We then go on to explain that we work independently of one another to tell two completely different stories that, combined, paint a very complete picture of their day. Our business sounds very different.

We explain that one of us shadows the bride and the other shadows the groom early in the day. We go on to say that during the ceremony, one of us is in the balcony focusing on the first time the groom and the parents see the bride and the other is below focusing on the moment the bride walks into the church. We describe the fact that while one of us is capturing the formal group shots at the alter after the ceremony, the other is at the reception site getting images of the tables, room, and details before the guests arrive and move things. Even during the reception, we shoot from different perspectives during the first dance, cake cutting, and other moments to ensure that they have a great variety of images.

While our services may not completely differ from those offered by other photographers, we emphasize just how structured our services are and how extensive our coverage is. We paint a picture that sounds unique and impressive.

In addition to highlighting our strengths, we ask a lot of questions about the wedding day *and* about the couple. If we have things in common with them—perhaps a love of the same sports team or wedding style—we can use these commonalities to sell ourselves. In psychology, this is called mirroring. People like to work with people who remind them of themselves. We take this to an extreme and even try to mirror the demeanor of the couple during the meeting. If they are a very relaxed couple, we will be more relaxed while meeting. If they are a little bit more engaging and sit at the edge of their chairs, we do the same.

Ultimately, your goal is to make sure that your prospective clients are impressed with the services you offer and find you likable enough to want to spend an extensive amount of time with you after booking your services. This doesn't mean being someone other than who you are, it just means that you will package your services in a way that appeals to the person you are meeting with.

Call to Action

It is important to wine and dine your clients during the meeting and sell them on all of the finer points of your service in order to convince them to book you for their wedding day. However, if you do all of this work and don't give them a sense of urgency to book you, then you could be letting a client walk away. We have never once asked a client to sign a contract or inquired as to whether they were ready to book us. Our typical routine is to give them all of the information that we feel they need and leave things open ended so that they can go home, discuss things, and call us back with their decision.

We understand that they may feel obligated to meet with other photographers before making their final decision.

It is important to not give clients the impression that there is no expiration date on their ability to hire you. The farther you get from your meeting, the greater the number of competing photographers the clients may meet with, and the more likely they will be to forget some of the great points you made to them during your meeting. We *never* pencil a date in for someone unless we have a retainer and a contract. When you tell someone you will tentatively hold a date for them, you give them the freedom to shop around knowing they have you in their back pocket. We let our clients know that we have several meetings lined up for our open wedding dates and that our calendar is constantly changing, so the only way we can reserve a date is to book it. We routinely mention that their date (no matter what it is!) is popular and that we are taking calls daily, so we can't take a chance on losing a booking for a "maybe."

These prompts can make clients want to book quickly, but why not increase the

urgency? Several years ago, we had the opportunity to sit in on a lecture by Mark Garber and Jennifer Gilman about their wedding photography and marketing tactics. During the lecture, they mentioned a closing technique that worked for them. We immediately put it into practice and have had great success. In fact, we were closing over 80 percent of the couples we met with in less than a week of the initial consultation.

Garber and Gilman had created what they called a signing bonus. This was basically a list of items that the bride and groom would

Find items that not only appeal to potential clients but can add to your bottom line in order to entice clients to sign quickly.

Signing Bonus

Free Engagement Session (local and weekdays only)

Free Bridal Portrait Session (local and weekdays only)

*25 Save the Date Cards OR *25 Thank You Cards

*Free Engagement Signature Folio

8-10 Wedding Image Blog Post

Blog Boards for Facebook

$100 Parent Wedding Album Credit

*Signing Bonus items are lost and voided if not used or redeemed by wedding date and cannot be transferred or exchanged. Printed cards must be created and printed with studio's lab. Signing Bonus is only valid when wedding photography services are booked within 7 days of the initial consultation- no exceptions.

get for free if they booked their wedding photography services within seven days of their initial consultation. If they signed after the seventh day, they would have to pay if they wanted any of the items on the list. The key was that all of the items in the signing bonus either cost them nothing at all or very little. In fact, many of the items offered in the signing bonus actually made them more money.

At our studio, we offered coupons for $100 off parents' albums, which could be used for both sets of parents. We added $100 to the price of the parents' albums to offset this. With the coupon, parents purchased nearly four times more parents' albums than in previous wedding seasons. We also offered a free engagement and/or bridal session. Both sessions only cost us time but resulted in portrait sales. Another

signing bonus for us was an engagement signature folio, a two-page booklet with a couple of images from the engagement session that their friends and guests can sign. The folio costs us less than $20 assembled, but we show a ten-page version that clients can upgrade to, and nearly every client takes that option. You might offer free portrait sessions for life; this would encourage them to continue to use your service for portraits after the wedding, and you would be able to make money from the print sales. Save-the-date cards or thank-you cards are another great bonus. You can offer 25 for free. Most clients will need more than 25, and when they order the extras, they will not only cover your costs but will add profit.

When using a signing bonus, set a clear and not-too-distant expiration date and choose items with a great perceived value.

Giving the wedding couple added incentives to book your services makes them feel like they are winners by choosing you to document their wedding day.

If you give everything away in your lowest-priced packages, you will not have given your clients a reason to spend more.

Clients should feel at risk of losing something of value should they delay in signing up for your services. Also, make it clear that the items have no value that can be applied to package. You don't want them to come to you and say, "If we don't want the engagement session, can we lower the price of our package?" You may also want to include an expiration date on certain items so that they are used before the wedding or within a certain period after the wedding.

Work Less, Make More

A common mistake for photographers, especially those who are just getting in the wedding business, is the feeling that they should compensate for a lack of experience by adding more time to their packages. Offering unlimited time on the wedding day is a huge mistake. Your coverage should be clearly defined. Offering open-ended quantities of anything, especially time, can come back to bite you.

If you haven't clearly defined how long you are going to work at a wedding, how many breaks you will get, and how long those breaks will be, then you can end up working twelve to fourteen hours or more. Think about working the equivalent of two straight work days without a break, standing for almost all of it, and carrying your gear. At the very least, put a cap of midnight on the wedding day, as going past 12:00AM results in you working on the following day

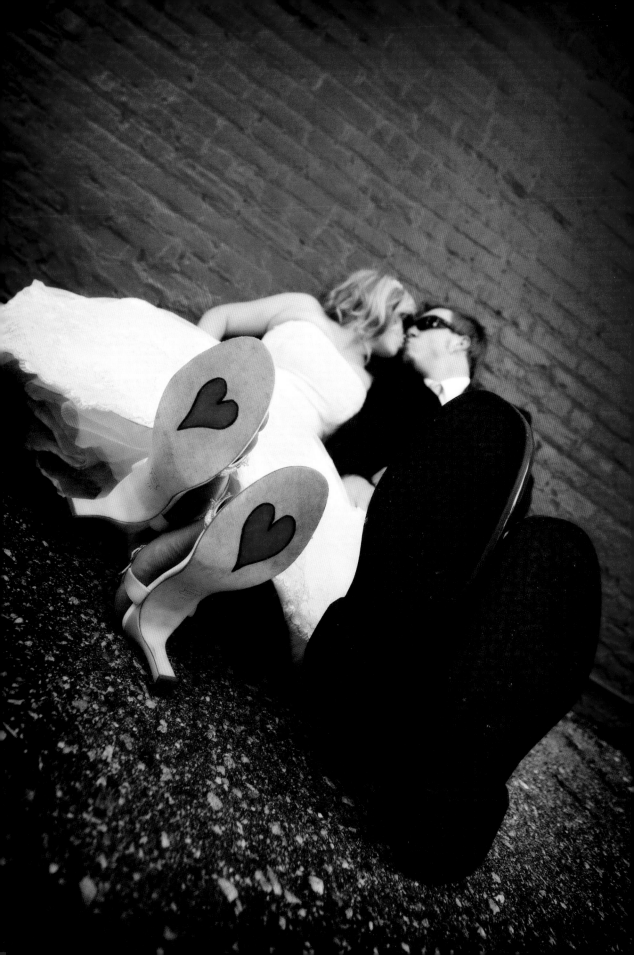

*"Set a timeline for a
basic package and offer other
packages that cost more
for longer coverage."*

as well. If you do not set limits, clients will find ways to manipulate you.

When we first started shooting weddings, we often found ourselves shadowing the bride and groom beginning at 8 or 9 in the morning with a ceremony that wasn't until 3 or 4 in the afternoon and a reception that would go past midnight. We found that we were exhausted and unable to give our clients the energy they deserved at the end of the night. Often, the images that we took in the early part of the day were never used in the album. We also found that while the wedding party spent most of the morning taking it easy, they expected us to run around taking photos.

Realistically speaking, almost everything that a bride and groom need to have captured on the wedding day will happen within eight hours or less. Things happen outside of this time frame, of course, but they are rarely critical aspects of the photographic story. As a photographer, your most valuable asset is time, and time is money. Set a timeline for a basic package and offer other packages that cost more for longer coverage. As photographers, we are always looking for ways to add value to our packages and

previous page—Giving couples options to book your services at a lower cost by letting an associate cover portions of the wedding day without you gives you a shorter workday while while allowing you to set your full-day services at a higher rate.

give clients a reason to purchase something beyond the smallest package. Offering packages with expanded hours of coverage is a great solution.

Pro-Share and Pro Wedding Packages

Over the years, we got to the point at which we looked for ways to make the same amount of money or more while spending less time at weddings. It wasn't that we don't enjoy being at weddings—we love shooting them! We simply learned which of our services our wedding clients most value: the photographs we take before the ceremony, when they are putting on the finishing touches of getting ready for the day; the ceremony; the images we create immediately after the ceremony; and the photos we capture at the very beginning of the reception. The remainder of the reception was less about our unique talent for capturing memorable, artful images and more about getting candids of friends and family dancing and having a great time.

Based on that knowledge, we created a series of packages for clients that lets us focus on the first five hours of the day when the most important things happen; we then have an associate come in for the last three hours to capture candids. We call these our ProShare packages. This plan allows clients to book with us at a lower price point but have coverage for the full amount of time they want. Offering this service allows us to make the amount of money we want to photograph a wedding, spend more time with our family, and limit the exhaustion that comes with photographing a wedding.

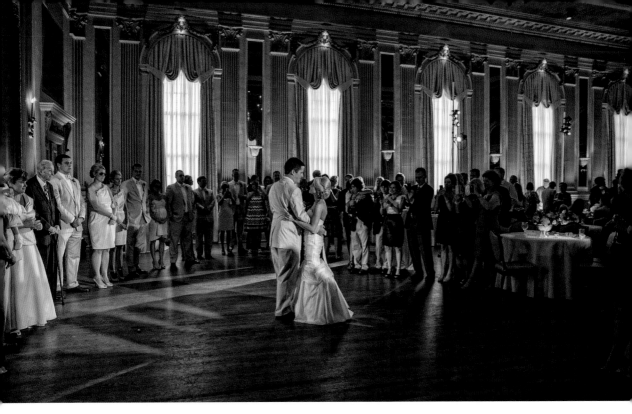

The client consultation often makes photographers feel as if they are on stage and everyone is looking for their flaws. The reality is, if the client is meeting with you for a consultation, there is something that made them want to book your services. Create and environment that makes you and your client comfortable when you meet.

When we created the Pro-Share package option, we didn't lower the price of our services. Instead, we created a second-tier package called the Pro package. These sessions cost more and allow clients to keep their first shooter working throughout the day. So, we essentially raised our prices without really raising our prices. We made the same amount of money as before but worked three hours less every wedding—or, if the client chose, we could work the full wedding day and make more money than before.

Adopting creative ways to add value for your time can keep you from burning out while you work hard to do something you love.

The Consultation

When you have only spoken with a potential client once to set up a meeting, it can be nerve wracking to meet in person, since these meetings are the key to your livelihood. For some people, meeting clients and pitching services comes naturally, and they enjoy it. Others are nervous, and they will find that preparation is everything. Whether you are an introvert or extrovert, you will find that carrying yourself with confidence is key to your success.

The location at which your consultation is held sends an important message to your clients. For years, we met clients at our home, a place we made cozy and com-

fortable for our visitors. The pros of this arrangement were many: we were in a place familiar to us—our home turf—and everything was easy accessible to us. The major bonus was not paying rent for the space, so we saved many thousands of dollars per year. We made sure that the meeting area was clean and inviting and that we had the necessary furniture to ensure our products were properly displayed and could be shown easily. Many people liked this setting because it was like visiting friends and not an actual business meeting. As a result, we booked quite a few weddings—even big weddings. Not having a fancy studio did not seem to play a part in the buyer's decision to book us. The major cons were having to maintain the house in perfect order all the time, the investment in keeping the grounds pristine year round, and the fact that we never left work. We were able to work around the clock, which interfered with sleep patterns and general life. While others had a pattern to their day, we didn't. We were often up until 4AM working.

Our home was our studio for years, until we determined we needed work-life separation and leased a space to get our lives back in order. We had also heard and were convinced by numerous colleagues that having a separate location would boost our bottom line, as we could charge and command more for our services and appeal to more potential customers who believed the business had an actual business location.

For our first studio, we found a building with enough room to accommodate what we needed—an office space, a meeting space, a camera room, and a storage area for props. The pros have been all the great space and ability to meet clients and have sessions in a separate space from our home. The only real con of having a studio has been the great expense of renting and absorbing the cost of telephones, Internet service, and anything else needed to run the studio daily.

When we set up the studio, we painted each room to convey a warm and inviting feeling. We invested heavily in nice furnishings and displays and in sample products for our meeting/sales room. When we met clients at our studio, the first impression was key. Upon opening the door, the gallery had low lights except for a few lamps and track lighting showing our large portraits on the wall and various sculptures and art pieces around the room. Anyone who entered the space was aware of the art in the room. This is what we wanted; we wanted to convey the impression that our work was art.

Before each consultation, we set up menus in the meeting room. These menus listed various coffees and teas available. We also offered chocolates for our clients to enjoy. Many brides and their moms loved the extra attention. There was one mom in particular who was so excited about choosing from the menu of coffees, she told us she felt so special being catered to. That was the best compliment. We knew that going the extra mile had paid off.

"Our home was our studio for years, until we determined we needed work-life separation and leased a space to get our lives back in order."

Time to Listen

During the meeting, our conversation is light. We get to know our visitors, we learn how they got engaged, and hear their unique story. Some shy clients will not go into much detail, but we make the effort to connect in some way. Many times, the grooms don't say a word, so connecting with them is especially important. You want to reach the bride on a personal level, but having the groom vote for you when it's time to choose a photographer will definitely increase your odds of booking the wedding. This also is true for the parents who attend the meeting. It is a plus to have the person making the financial decisions for the wedding on your side. Know exactly what you want to say, rehearse it, and be confident in your skills and experience. Let the clients know what you can do for them that your competitors can't or won't take the time to do. Many times we have been booked over other photographers simply because we want to play a part in the planning for the day so we can help make the event wonderful for them and great for us to photograph—it's a win-win situation. The photographers who book a client and aren't heard from again until the wedding day are simply punching the clock; they miss the opportunity to connect with clients who could refer their friends and family in the future.

After you have covered all the necessary information, be prepared for questions. Discuss money last. After we have gone through our services, we present our pricing information, which the couple can keep and review later. Over the years, our price list has evolved into a simple small package with an individual price sheet detailing each wedding collection. It is wrapped in ribbon, like an elegant wedding invitation. It has always been our policy to let clients know they are welcome to call or send us a message if they have any questions. We never push for a final decision while they are meeting us. We give them time to go over everything, as we understand it is a big financial decision. We are confident that after they review everything we have provided, they will see that we are a great choice for their wedding photography. Many couples e-mail us the night of the meeting to let us know they would like to reserve our services, and we promptly send them the necessary paperwork to book the date. There have also been those really great instances when we said our good-byes, the couple walked to their cars, chatted a few minutes, then turned around and knocked on the door because they were ready to sign a contract!

Once you have conducted a few consultations, you will begin to anticipate common questions and will know exactly how to answer them. Being polite and being yourself will help your clients connect with you. Keep in mind, though, that not every client will be a good fit for your services or personality. You are under no obligation to say yes to everyone who walks through your door. If it is clear that what the client is looking for is not something you provide and

following page—It's important that you spend as much time showing interest in your clients by asking them questions as you do telling them about your services. Make sure your consultations aren't one-sided conversations.

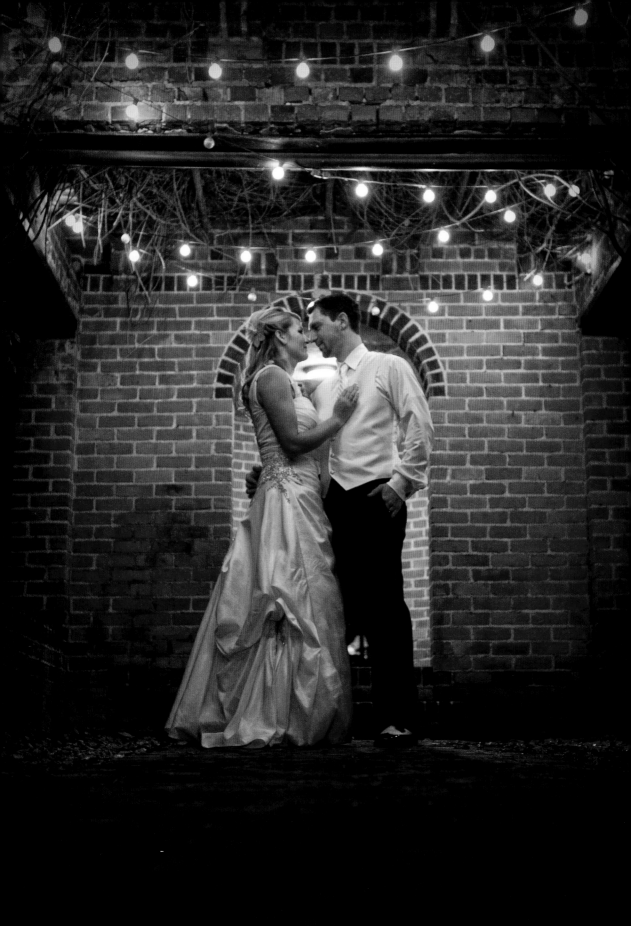

another photographer will be a better fit, recommend someone who will be a better match. The saying "money isn't everything" could not be more true in these situations. Having a bad relationship or miscommunication with a client can hurt you and your business long after the money has been spent.

Money Talk

If you jumped into the wedding industry like we did, knowing basically nothing about it, then you know that we banged our heads against the wall, trying to figure out how to price our services and products. We researched our competitors and paid close attention to those whose businesses resembled ours the most. We were not sure what we wanted to offer, but we were certain that we did not want to be the cheapest studio around. We knew right away that we would need to offer something to entice clients but would eventually increase our prices to reflect our experience.

Wedding collections used to include everything we thought the clients would want—hours of coverage, albums, custom cards, and prints. After some time, we found that clients wanted to swap products for something else. They had no use for or interest in some of the items we offered in our collections, so we removed them. After even more experience and thought, we created collections that included only the bare necessities and made the extras available at an additional cost.

Every time we increased our wedding collection costs and wedding service prices,

Finding the right balance of products and services when creating your packages ensures that your clients have options that fits their needs. It also allows you to give them the opportunity to move up to larger packages.

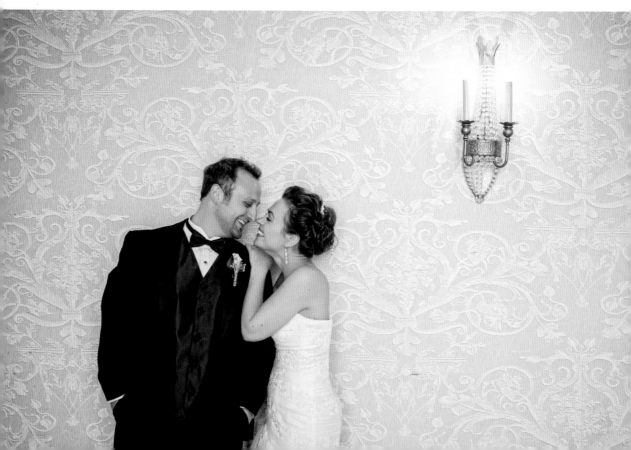

"Commanding what we are worth is key to our success and overall enjoyment in our careers."

we experienced sleepless nights wondering if we would book any weddings the next season. Of course, with great risk often comes great reward. We knew we were worth the increased investment because each season we became better photographers and learned so much more than the season before.

Commanding what we are worth is key to our success and overall enjoyment in our careers. If you price yourself too low at the beginning just to stay completely booked, it will be very difficult, if not impossible, to increase your prices later, since everyone will be used to your low prices. The threat of fewer bookings may stop you from trying to raise your prices. It is obvious that if you raise your prices, you will earn more and may not have to work as often, but until that happens, it's a waiting game you play, which may not be for everyone.

When you establish your wedding prices, consider two important factors: your region and the types of weddings you want to photograph. If you are looking for smaller weddings that you can photograph yourself and have less overall stress, then price and market yourself appropriately for those clients. If your goal is to work at the top venues, then consider what will be expected of you and at what price. Photographing weddings requires attention to detail, anticipating events, and much more work after

the wedding than anyone can imagine, so calculate your time, think about your talent and expertise, and generally consider what type of lifestyle you expect to have while working in the wedding photography industry. Most people have a dream to work for themselves, but it comes at a high price with many sacrifices. Make sure you set yourself up for success and a prosperous future.

Get It in Writing: Have a Solid Contract

Your clients are ready to sign your contract, but before you get to this step, be sure you have covered all of your bases and have combed through every section of the agreement so there are no future regrets. Once the contract is signed, you and your client are bound to the terms; at least this is what you assume. As is often depicted in courtroom dramas, a contract can be argued in court and you could potentially lose a small fortune if you don't spell out everything clearly and precisely. The Internet provides an abundance of free contracts and templates, so do your research and find one that covers all the services your business provides and avoid any major loopholes.

General contracts outline who the contracting parties are, what services are being rendered, the time frame for the services, and basically what happens if any part of the contract is breached by either party. However, when you are talking about one day—the most important day of a family's life, someone's wedding day—there are no refunds or changes that can be made after the event has taken place that will satisfy an unahppy client. There is no "do-over," so what you

Although the parents may be the ones paying for your services, your actual clients are the bride and groom. It is important that the couple signs the contract.

spell out in the contract you provide is what will be expected of you, and nothing less. It does not matter if what is seen as an act of God takes place that impedes you from fulfilling your part. You are responsible for making it right.

In the early stages in our business, we repeatedly heard that contracts should be short and easy to read. After oversimplifying it, we discovered this advice could not be more wrong for our type of business. We had a client argue their way into us giving them products that they did not pay for, only because the wording in our contract did not explicitly state that these products were offered for an additional fee. A simple

word or two added to the contract could have made it 100 percent clear, but the mere suggestion of the available products allowed them to argue that it was implied they would get everything for free. With this we could not argue. It was better to allow this one instance to pass without any further struggle to offset the risk that this client would spread negative information about our business. We took care of the situation and immediately changed the contract to ensure we would never be in that position again.

As the photographer, it is assumed by many that you are responsible for ensuring that the portraits the client has requested are

to be taken, even when circumstances are beyond your control. You need to state in your contract, and tell your client, that you will do everything in your power to provide what is on their wish list, as long as nothing gets in your way of accomplishing this goal. For instance, we had a very affluent family contract us to photograph their daughter's wedding. The importance they placed on the wedding images was clear to us. We were prepared for the grand event and were excited to capture great images of this very good-looking couple at some of the most sought-out venues in our city. Much to our surprise, photography was not allowed at the church—*none whatsoever!* We had to put our cameras down. Not one photo was to be taken until the bride and groom recessed after the ceremony. With these type of restrictions, we were unable to document the most important part of their event. It was out of our control. A vital part of their wedding album and their story was missing.

Other items to consider adding to your contract are lack of coverage due to weather conditions, scheduling complications due to lateness of individuals, rules and restrictions of venues, or the rendering of decorations of the location. How a room is laid out for an event can certainly limit your ability to shoot from various angles and perspective. Also, be sure to explain what happens if the wedding date is canceled or changed. Will you keep

the retainer fees or provide a refund? It doesn't happen often that a wedding doesn't take place at all, but it *does* happen, and having to return funds that you collected over time but did not technically earn can put a real damper on your long-term financial outlook.

Be Flexible

Once the client is ready to book your wedding services, it's time to determine the collection they would like to purchase so you can create a contract and collect the retainer fee. We have set up strict policies to ensure this part of the process is efficient and effortless. We know booking our services is a financial investment for many, so we want to make it as painless as possible. We accept various forms of payment and offer payment plans to allow for more financial flexibility. The best part of offering a great payment plan is that is secures future and predictable income for you and allows the client to spread out the payments over time, potentially opening their budget to buying more from you.

A grave mistake we made early in our career was allowing too much flexibility. We broke down the cost of the collection into three payments, with the last one paid within a specific period of time right after the wedding. Alarms should go off about now. Why was this a mistake? Well, people can overextend themselves. Sometimes the reception goes well over budget and last-minute expenses can add up, leaving no other available funds once the fun is over. We were left trying to collect our final payment after the anticipated event had passed. We didn't

"We know booking our services is a financial investment for many, so we want to make it as painless as possible."

provide the final high-resolution images until the last payment was made, but that was not enough of a concern to some who could not get their last payment together. This makes for a not-so-great end to a long working relationship. Be smart: spell out everything in writing and collect all of your fees before the event ends.

Another thing that helped our business income and financial outlook was providing a monthly payment option, which quite a few clients enjoy. This allows for small payments until the month of the wedding, versus three large ones. The retainer fee is sizable to ensure the client takes the contract seriously and doesn't back out of our agreement with only a small payment to forfeit. We then break down the remaining balance into monthly sums. The monthly funds we are scheduled to deduct from various clients boosts our income during periods of time when bookings are low.

No matter what type of payment options you choose to offer your clients, be sure to protect yourself and your investment. You have a business to run and possibly a family to take care of. Making sound judgments early on can prevent a lot of headaches. You can be flexible, but don't let others take advantage of your kindness and willingness to help.

previous page—Offering flexible payment options can make it easier for great wedding couples to afford your services.

What If . . . ?
Wedding Cancellations

You hate to get to know a client and look forward to their wedding only to learn that the wedding has been called off. Luckily, we have only faced a few cancellations in our career. Still, knowing how to handle the situation is of utmost importance; it is a stressful and painful time for both families.

We created a form that outlines the course of action we will take should we lose a booked date. Our form and contract state that the first payment secures the date and that once the payment is made, we block off that wedding date so no other events are scheduled. Therefore, a cancellation results in lost income. Although we make every effort to rebook the date, sometimes that is not possible—especially if the event is called off just a few months before the wedding. We state that we need a minimum of six months to try to re-book the date but do not guarantee that we can book it. If we are able to re-book the date, and the new contract is of equal or higher value, we will simply release the client from their contact. We also stipulate that should they change their wedding date, the new date must be during our non-prime months if they are to transfer any of the retainer fee. This transfer is really done because we care for our client and understand some things (such as being on active military duty or suffering from health problems) are beyond one's control. We also understand that other vendors will not refund a penny; this could be detrimental to the family that has paid countless retainers and deposits. We definitely do not want to be a source of stress or resentment

Cancellation of Wedding Photography

Cancellation of services may result in loss of income for the photographer because of inability to re-book the date. The closer the cancellation is to the day of the wedding, the less likely it will be booked. As described in the original wedding contract, all reservation/fees are **non-refundable**. The photographer will attempt to re-book the date. If the client reschedules the wedding for a future date, all fees paid will be applied to that new date, subject to availability and collection purchased, and if it is during a non-prime month (non-prime months are list months). If rescheduled wedding date is during a prime month, a new initial retainer fee will be required (prime months are list months).

We have read, understand the above mentioned information, and agree to the above terms and hereby release studio name from any contractual obligation to perform photography services on cancelled wedding date.

_____Date_____
Clients' Signatures (Bride and Groom)

Clients' Names (Print)

mm/dd/yyyy
Wedding Date Canceled

_____Date_____
Photographer Name
Studio Name

above—While you hope that all of your weddings will go smoothly, it's important to be prepared for any situation. *left*—If a couple cancels their wedding date, you are still technically bound to them for the date if they paid you a retainer. You can't start looking for a replacement wedding until they have signed something to release you from your contract.

to the families. However, this is at our discretion. According to our contract, we keep the entire retainer we required to reserve our services. We can't have a client change a wedding date and end up taking two prime dates for the price of one without some type of financial consequence.

Receiving the completed cancellation form signed by the original contracting party is important, as it releases them from future payments as outlined in the contract. It also frees the photographer from being obligated to photograph the event and everything else that was promised in the contract. This part of the business can be handled as you see fit, but do know your state's laws regarding the contract signed and actual money earned from work you

have done. If you have not completed the work specified, then you may not be able to pocket all the money the client has paid thus far. Be savvy and always read the fine print.

Do Your Homework
We make it a habit to research as much as possible any venue in which we haven't yet worked. Our thinking is, if a client trusts us to capture their wedding day and they have paid us well, then we owe it to them to provide the best-possible service.

As we build to the wedding day, we start gathering information from our clients about the ceremony location, the reception location, and any potential spots at which we might be shooting between the two events.

Once you have booked a wedding, it's important that you invest time in getting ready. Visiting venues that you have not worked in before and checking out locations where you can get great pictures on the wedding day can help to ensure great results.

We like to visit the ceremony site before the wedding. This gives us an opportunity to introduce ourselves, find out the rules for photographing, and scout out the best places to shoot from. We have found that when we make this effort and learn the rules, the church staff often loosens up and gives us a little extra leeway, so long as we don't abuse the privilege.

Our belief is that the couple knows what the rules are when they select the venue for their ceremony. If the church has very strict rules and only allows us to shoot from the balcony or from the very back, then the couple should expect only that. They can't be disappointed if you miss shots because you had to play by the rules of the church they selected. However, we have always been respectful of churches and let the staff know upfront that we don't shoot with flash during the ceremony, we never click during prayers, we move discreetly as we don't want the guests looking at us instead of the bride and groom, and we never walk up the center aisle. Letting the church staff know that you respect their facility before they even start giving you their rules goes a long way and may get you on their referral list.

We make a visit to the reception venue before the wedding day as well. We schedule a time to meet the staff and get a brief tour and rundown of the layout for the couple's reception. This allows us to see what type of lighting challenges we may face, identify any obstructions we may need to be prepared for, and determine the best places to shoot from during key moments of the reception.

More importantly, this meeting allows us to create a new relationship with a vendor whom we may not have worked with before, and often that vendor is impressed that we take the time to do our homework. This, plus doing great work on the wedding day, can lead to great referrals.

Lastly, we stop by any other locations that the bride and groom have in mind for pictures. While at these locations, we check to see whether there are any festivals or events that will be held on the wedding day and could present a problem. We also make sure that we have permission to shoot there and, if need be, apply for any permits. We make sure we know where we will be permitted to park, too. The last thing you want to do is show up to shoot an event and realize that you can't deliver the images you had promised the couple because you didn't do a little legwork. We always make an extra effort to look for spots where a stretch limo or party bus can park and turn around in easily. This not only makes things easier for them but saves time in getting from one location to the next.

While we are at any of these types of fun locations, we are sure to look around and see how many useful spots there are to use so that we can make the most of that spot. We try to find an area in which to photograph the bride and groom together, another spot to photograph each of them individually, a spot for all of the ladies, a spot for all of the guys, and another spot for the bridal

party. Our goal is to find enough completely different locations in one destination that it looks like we visited several different places. Making this site visit in advance allows us to be decisive and flow quickly on the wedding day so that we can get more images than the couple are expecting.

We try to make all of our site visits at about the time of day that we will shoot on the wedding day so we can see what the light will be like. Knowing how the light comes through the church windows or if there are areas of harsh light at a park will help you be prepared on the wedding day.

Develop a Plan

A big step for us in being ready is working closely with our clients to develop a plan for the wedding day. Not every couple hires a wedding planner and, even if they do, not every planner works with you before the wedding to make sure you are up to speed with everything that is going on. Furthermore, they may not know your timeline for photographing.

We plan to have a consultation about thirty days before the wedding. We ask the couple to fill out a vendor and location form so that we have a list of every vendor we will be working with, the addresses of all locations, and the phone numbers for staff at each venue. This form is a quick reference for us for preplanning, and on the day of the wedding, it provides the information we'll need should we submit images from the event for publication.

We also create a customized plan that outlines the time we will be working, when

A few weeks before every wedding, we like to meet with our clients to make sure we are aware of all of the details of their wedding. Knowing not only the things they have planned for the day but also what to expect in terms of the decor helps us to prepare.

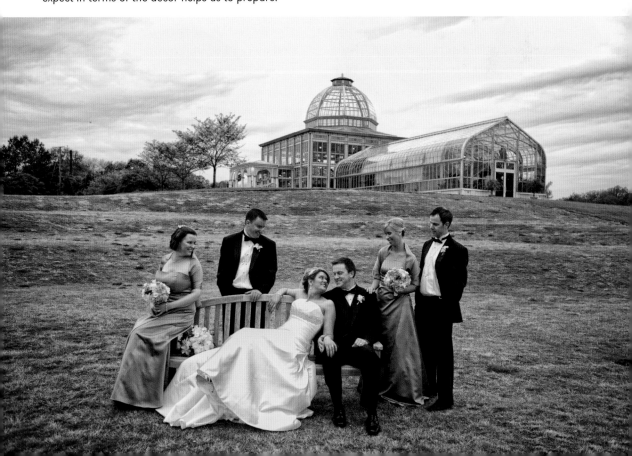

"If you're unaware that something will be taking place, you may miss the opportunity to photograph it or find yourself in a poor location."

important events are going to happen, and roughly when certain photo opportunities will take place. We often start at the end of the night and work backwards so the couple can see, based on the time we are going to be leaving for the night, what time they should expect to see us. If the couple booked us for an eight-hour package, the reception ends at 10:00PM, and they want us to stay until the end of the night, they can expect us to show up at 2:00PM. If the timing works, discuss how far along they should be with hair and makeup and getting dressed for the pre-ceremony images. If the timing doesn't work, we either find a way to adjust the back end to leave a little earlier so the client can gain more time on the front end or the client can add extra hours of coverage. Usually, our clients have booked a package with enough hours in advance and we just need to adjust the timing to accommodate the things that are most important to them.

Once we have determined a start and finish time, we go over all of the details of the day. We begin with the locations where the bride and groom will be getting ready and get as much information as we can about those spots. Knowing how many people will be there getting ready and what kind of environment it will be can help us provide

a little guidance and ensure everything is ready for the wedding day. There is a big difference between a bride and eight friends getting ready in a Sunday School classroom and a bride and three bridesmaids getting ready in an executive hotel suite.

We also discuss the actual wedding details. We want to know what colors they are using, the types of flowers, how big the centerpieces are, whether there are party favors, what the cake is like, and if there is event lighting The more details we can nail down, the better job we can do of capturing as much as possible and making it look its absolute best.

We go over every minute of the day to note when special events will happen—like cake cutting, dances, and toasts. We also ask whether there will be any events that may be out of the norm. If you're unaware that something will take place, you may miss the opportunity to photograph it or find yourself in a poor location to capture images effectively. Having these discussions and finding out how much time they allow for us to capture the images they want is crucial to make sure things go smoothly.

We follow up with a call or e-mail the week before the wedding to see if there are any changes or additions that we need to be aware of and to give the client one last dose of assurance that it is going to be a great day and we are going to have a great time working together.

Plan Detours and Pit Stops

We strive to create fun and unique images for our clients. We actively plan to make these images happen; we don't wait around

One of the exciting parts about the build-up to a client's wedding is coming up with a plan for great images. Finding unique locations on the wedding day can often make for some great images for your clients—just be aware of any rules, hazzards, or events that might put a damper on your plans.

hoping that an interesting opportunity presents itself. We have planned pit stops where we can take some great images in scenic locations. Word about this has gotten out, and we feature these images on our website, so the clients who book us have come to expect that we will take a detour on their wedding day to create some special images.

These pit stops allow us to create fun and different images of the bride and groom together and individually, the entire bridal party, and then just the ladies and just the guys. It gives everyone in the bridal party an opportunity to show their personality and loosen up. Some clients consider these stops the highlight of the day. Many of the guys

have said it was the first time they had fun having their picture taken.

Every couple is different in when and how they want to create these images. Some couples want to have a first look where they are given an opportunity to see one another before the ceremony (this is covered in a later chapter) so they can get all of the photos out of the way and go right from the ceremony to the cocktail hour/reception. Others want to savor the special moment when they see each other for the first time and create images after the ceremony while the guests are at the cocktail hour. We don't push either approach; we know that it is a personal decision the couple must make.

previous page—It's important to work with your clients on their timeline to ensure that they have enough time to for you to create the images they want. Establishing a game plan can also help you to make certain that they have realistic expectations of what you can achieve for them in that window of time.

Once we have established when we will do the detour, the next step is to determine how much time we will have. This will help us decide where we will go. If we are shooting a wedding where everything is taking place at a single venue, we may seek out unique spots around the grounds to capture those special images. When the ceremony and reception are in two different places, we present the bride and groom with some location ideas that are en route from one spot to the next.

Discuss the Timeline

Making sure other vendors are happy is crucial to your business success, as you will need the vendors' referrals down the line. One way to accomplish this is to be prepared for the wedding day and do some homework to ensure that you adhere to the timeline. Just because the bride and groom are following your lead on the wedding day does not mean that you can take your time and neglect the other planned events of the day.

Arriving at the reception venue late due to improper planning can cause many problems. For example, the caterers' and chefs' food preparation is carefully calculated and timed to ensure safety, great presentation, and flavor. When you cause delays, all the evening's events will be delayed, making you the villain in the eyes of all those vendors who expect things to happen as scheduled. If anyone complains about problems that arise due to a botched timeline, rest assured the finger pointing will be directed at you.

We require that our clients or wedding planners provide an events timeline a few weeks before the wedding. We typically meet with or call our clients to discuss the timeline and ensure that there aren't any potential problems they may not have accounted for based on our previous experience. Some timelines are very tight and do not account for travel time to the various locations, which means that no matter how hard you try, you will certainly be late if there is a delay due to traffic or any unforeseen incidents. Even the most carefully planned timeline can be thrown off if a wedding party member or family member cannot be found when the formal portraits are supposed to begin or the limo gets in a fender-bender on the way to the reception. Allow a cushion of time; it is essential to maintain everyone's sanity.

Props and Items to Bring

Often our clients will want to try to make their fun photos more personal. When we sit down to discuss these images, we usually start by talking about specific locations. There are times, however, when the places we have in mind do not convey the feeling that the clients want. While they like the spot, they may want to do something more.

In cases like this, we talk about the couple's individual interests or things they enjoy doing together. Often, we can incorporate certain props into the images that give that

personal touch and really capture who the bride and groom are as a couple. You may have a couple who enjoys hiking together; you might capture a few shots of them wearing their hiking boots with their wedding attire. You might also create a theme around a sport they enjoy, musical instruments they play, a special car or truck, or their pet.

The sky is the limit with these images. The most complicated part is making sure your clients remember to bring any props that are needed. Whenever we are going to create an image that incorporates props, we work out the details in advance. The more we can visualize what the image will look like, where it will be captured, what we will need, and how long we have to create the shot, the better the odds are that we will create something magical for our clients.

We try to meet with our clients in the days before the wedding to pick up any props. If a prop they plan to use is valuable, we ask the couple to choose a trusted guest to bring the item on the wedding day so that we are not liable for it. We also try to secure the location for the shot in advance so we know exactly how we will stage the image and are aware of any challenges or distractions that may detract from the prop(s) being used.

Bringing small items that can be used to create fun images for your client can add to the quality of your images and your client's enjoyment of them.

Knowing what type of wedding details you can expect to see on the wedding day will allow you to brainstorm ideas as to how to incorporate them and create memorable images.

Doing a little homework and legwork can go a long way. When it's all over, you may have an *epic* image, or perhaps something simple, but you can be sure that the photograph will be meaningful to your clients, and that's important.

First Look

A popular trend over the last several years has been the first look. It is an orchestrated moment in which the bride and groom see each other alone, but within view of the camera, for the first time on the wedding day. They are able to share a few private moments. The benefit of this is that the couple can get all of their formal and fun photos done before the ceremony so that they can fully enjoy the cocktail hour and reception.

Every couple has different feelings about this and must make their own decision about how they want to handle their photos. Our policy has always been to explain how the first look works and allow the couple to decide what they want to do, without any pressure. In the southeastern United States, tradition plays a heavy role in weddings, and many couples believe strongly that the bride and groom shouldn't see each other on the wedding day before the ceremony. Who are we to buck tradition?

When we describe the first look, we tell the couple that we find a location for

the meeting to take place that is relatively private but photographically pleasant. We choose this space based on what is available to us, gives us good angles from which to shoot, and is a nice distance away. From there, we explain that we will have the groom stand in the spot we select and ask that he not turn around until he feels a tap on his shoulder. We typically ask the bride to tap on a specific shoulder and for the groom to turn that way to see her for the first time. This allows us to be sure we get a great photo of the moment. We give the couple a few moments alone, and when they give us the signal that they are ready, we step in and start working with them, their family, and the bridal party to complete their photos.

We explain that the first look allows the couple an opportunity to share an extra moment alone together that many couples don't have. We tell them that typically when the couple first sees each other during the ceremony, the father of the bride is usually between them and they can't really say anything to each other or touch one another until they are directed to do so by the minister.

With a first look, the groom can express to the bride just how beautiful she is, they can communicate their feelings to one another about the excitement of the day in their own words, and they can share a hug or a kiss. Later, at the ceremony, they will still have the butterflies, as they will actually be ready to get married, with all of their family and friends there as witnesses. There will be plenty of excitement and joy; little will be lost emotionally as a result of scheduling the first look.

previous page—Establishing a time for the bride and groom to see each other before the ceremony can give you lots of freedom to create some fun images. *right*—Remember to step back and let the first look be a special time for the two of them. You can often capture some magic if you are patient.

The biggest perk of doing a first look is that, depending on how early a couple decides to see each other, it can open up an ample amount of time to go to off-site locations and create great images with less pressure.

Many couples will weigh the pros and cons of the first look and decide what they want to do. We are perfectly content to carry on with the planning of their day and work out the timeline for how we will complete the various images we need to take.

Personal Wedding Details

A great publishable wedding is all about the details. When the flowers, cake, attire, linens, and other personal touches come together perfectly, a simple party is transformed into an elegant affair. Granted, not all weddings are publishable, but you should treat every weddings as if it is. Photographing a wedding should not be like punching a clock; don't go in, get the job done, and check out. Your clients invest a small fortune to have you capture a really special day, a great feat.

When we talk to our clients about their day, we discuss and document every little detail they have planned and try to envision what they want to accomplish. We want them to paint a picture for us so we can be well prepared for what we will see and make sure we don't miss the slightest detail. Many times, we collaborate and create an even better picture, which makes us more invested in the success of their day and shows our clients that we are truly a valuable asset. We have helped our clients with ideas for making their reception more grand, providing suggestions for incorporating ideas or adding items that cost nothing—maybe just a little time and labor. We are the experts and have photographed many more weddings than a typical person attends in a lifetime, so

left and following page—When selecting wedding details, the couple is able to inject their personality into the wedding day. Capturing images of those meaningful items makes for more personal, meaninful images.

top—Hearing feedback from the couple about anything they didn't love about their engagement images will help you to make sure that you don't take those same images on the wedding day. *bottom*—Look for ways to interject fun and personality into an engagement session. Knowing the couple's limits at this stage can help you to determine how much fun they will be willing to have on the wedding day. *following page*—An engagement session allows you to teach the poses that you will use on the wedding day so your clients will appear more natural in their wedding images.

will enhance them. Couples who really want to increase the odds of having their images published will take time to set aside special items to be photographed separately or early on in the day.

Engagement Sessions

For years, we have made it our mission to have an engagement session with every couple whose wedding we are photographing. We look at the engagement session as homework for the wedding day.

The engagement session is usually our first opportunity to interact with our clients as subjects and to start to build chemistry with one another in a photographic situation. During the session, they learn some of the terms we use and understand much

we've seen just about everything. We know what works and what will surely fail. Being able to guide our clients to making the details memorable is one of the fun aspects of what we do.

Once we know what types of details the couple will incorporate, we prepare for them. We think about the gear we need—such as special lights, lenses, or props—that

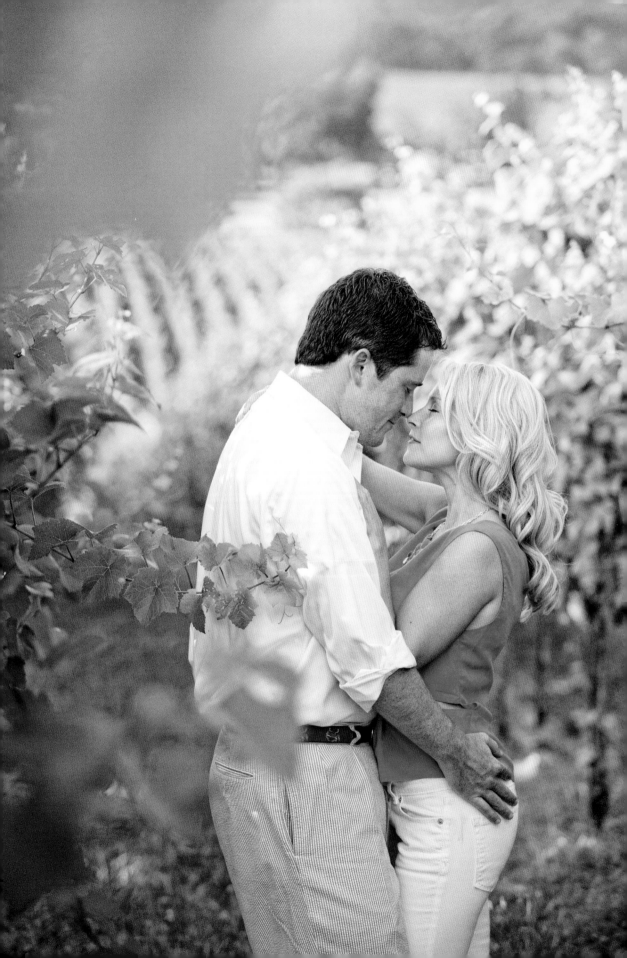

previous page—A bridal session is more than an opportunity to create additional sales. It is a dry run for the bride to find out if she needs to change something about her gown, shoes, or hair, flowers, etc.

of what we do when we are photographing them. We explain that much of what we will do in terms of posing and interaction will be used again on the wedding day. This experience helps to ensure that the couple is comfortable doing those same things on the big day.

We explain that we put the bride and groom in certain poses so that they can look their absolute best but still appear natural and relatively unposed. We refer to this as staging their bodies and creating a natural interaction. This entails making sure certain knees are bent, feet are positioned in a specific way, and hands are well placed and posed. Everyone wants to look good, so they tend to pay attention.

We go through several different poses based on the areas in which we are shooting. We try to create poses that suit the scene and can also be used on the wedding day. That way, we can make a quick reference to a pose by saying something like, "Do you remember the pose we used in the doorway when you had your hand on her hip?" That gives them a visual reminder and they fall quickly into the desired pose.

For us, the most important part of the engagement session is learning which images or poses the couple *dislikes*—and why. Having insight into the client's likes and dislikes makes it possible to craft images they love on their wedding day.

Bridal Portraits

Bridal portraits are a regional phenomenon. In some parts of the country, no one has heard of bridal sessions, while in others, it's a deep tradition and there is a framed 16x20-inch or larger canvas portrait of the bride on display on an easel for guests to see when they walk into the reception. Those of us working in areas in which bridal portraits are the norm know that a bridal session is a great source of extra income—and the display portrait at the reception advertises the quality of your work.

Much like the engagement session, we view the bridal portrait session as homework. All of our brides are familiar with these sessions, and most are excited about having their portrait session done, but we always have a quick conversation with them about it in advance. We explain to them that the session is a dry run of the wedding day and a chance to make any last-minute adjustments. We explain, for that reason, they need to prepare for the bridal portrait the exact same way they plan to prepare for the wedding day—they should have the same bouquet, the same hair and makeup, the same shoes, and the same jewelry.

In most cases, prior to this session, our clients haven't worn their gown for more than a few minutes at a time—and the only walking they have done was from the

"The most important part of the engagement session is learning which images or poses the couple dislikes—and why."

Much like an engagement session, the bridal session is an opportunity to teach the bride the best way to pose and look amazing in her dress so that her wedding images are absolutely breathtaking.

dressing room to the mirror. During a bridal portrait session, the bride-to-be will wear her gown for at least an hour and may find things that she wants to have altered or adjusted before the wedding day. The dress may be too long, and she may have to kick it as she walks so she won't step on it. The dress may be strapless and too loose or too tight and may need an adjustment.

The client may find that the hairstyle she has planned isn't what she wants and opt to change from an updo to a down hairstyle. She may feel that her bouquet is too heavy and want to change to something smaller or choose different colors. She may discover that her shoes will be tolerable for the

duration of the ceremony, but she will want to change before dancing at the reception. Most of our brides make at least minor changes due to the bridal portrait session and are glad to have had a chance to work out issues before the wedding day.

The bridal portrait session allows us to become familiar with the gown, learn the best way to pose the bride in it, and the various ways it looks best when photographed. Additionally, we are able to make note of key details in the gown that we want to emphasize on the wedding day. All of this knowledge gives us the tools we need to capture the best-possible images of the bride on her wedding day.

We typically photograph bridal sessions on location. Although we have studio space to photograph in, we take the opportunity to use various locations around the area to give the bride a portrait that is unique. We always talk with the bride about the type of portrait and location she envisions, then work to find the space that suits her vision. We sometimes work at one of the wedding-day locations, like the reception site, or a spot that they want to stop on the wedding day that is meaningful to the couple.

On the day of the session, we bring two things that are key to every bridal portrait session: lighting and a white, flat king-size bed sheet. Making sure we have good off-camera flash available means we won't have to turn away from a location that looks great but has poor lighting.

We bring the white bed sheet to put on the ground or floor before the bride drops her gown, or place it on a seat or bench before she sits if it is outdoors. This doesn't guarantee the gown won't get a little dirty, but it certainly helps limit the possibility. Once the bride is positioned, we carefully tuck the sheet under the edges of her gown so that it doesn't show in the images.

Bridal portrait sessions don't always have to take place in the studio. It's often good to discuss locations with the bride to find a location she is interested in to create a portrait she'd like to hang on her wall.

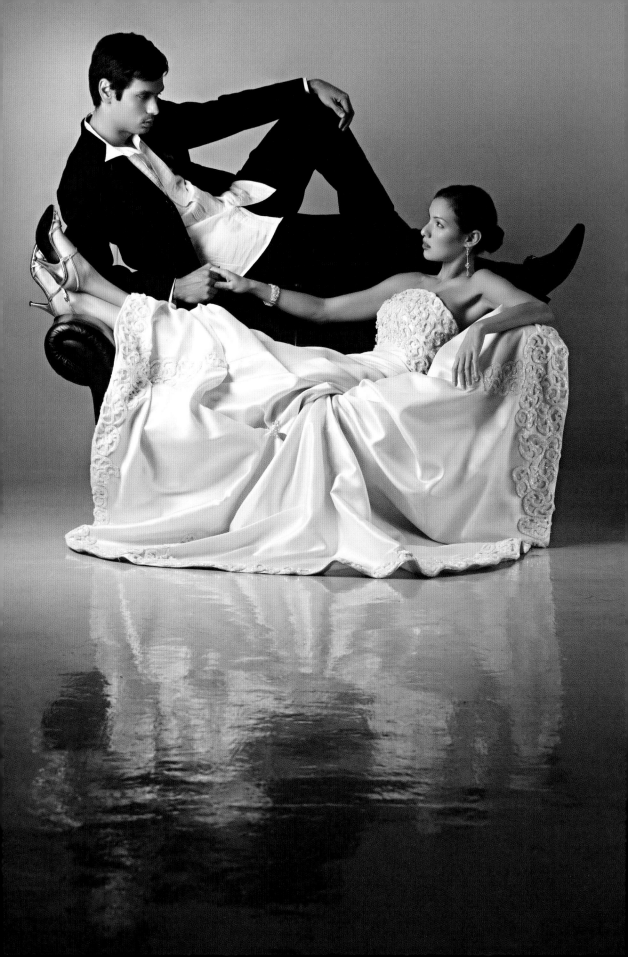

4. THE WEDDING DAY

Standing Out in a Crowd

We plan to capture epic images at every event. We want our images to stand out from those created by other local photographers. We have never made it a habit to just show up and hope that something cool happens. We put in real effort to create an image that's breathtaking and exciting. We look at every single wedding as an opportunity to create that next big image—a shot we can display on our website and showcase at the next bridal show.

To create high-impact images, you've got to visit the various locations you'll find yourself shooting at on the wedding day. Doing so gives you the opportunity to arrange for

previous page—Sometimes some of your best images are a product of looking at the potential in things others would pass up. A love seat and a reflective floor can make for the perfect setting for a quick, romantic portrait that is unlike the images that most photographers capture on the wedding day. *below*—Showing just a portion of your image creates impact. A quick crop can make a simple image an attention-getting shot.

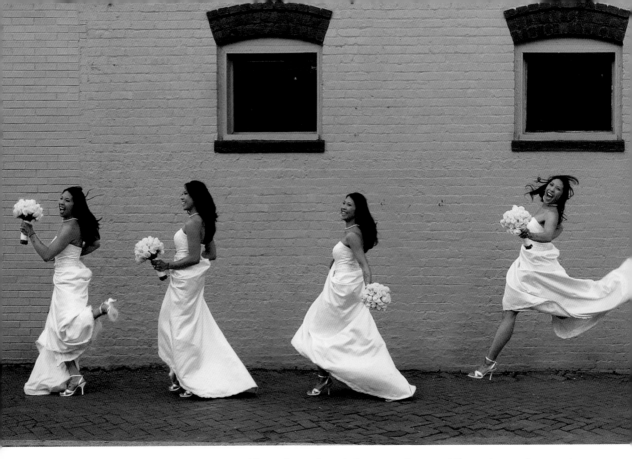

As photographers, we can't just stand by and wait for epic images to happen. We need to work to create them on the wedding day.

any additional lighting or props you may need to carry out the image concepts you have in mind. It also gives you the opportunity to discuss the image you have in mind with the bride and groom so you can get them on board. When they are aware of your plans for a really great image and are excited, you will get great expressions and body movements.

Sometimes the bride and groom tell us that they have a great idea for a portrait or that they want to do something really fun. That collaboration can be priceless; you have more members on your team to find the things needed to take the image over the top.

Some photographers find communicating their creative concepts to clients challenging. The easiest thing to do is find inspiration in the work of other photographers around the world and share their images with your clients. Don't give them the impression that you had anything to do with creating the inspiration image. Instead, share the photo and say, "This photographer created this image. I think it is amazing. We could do something similar with our own twist." If you take this route, avoid sharing images made by photographers in your area, as the client may go to that photographer instead. Also, consider doing a test shoot with friends or models to see what problems you

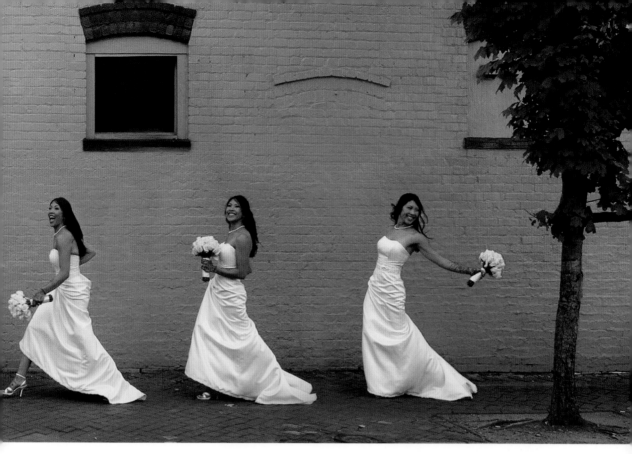

might face when you try to create this new image. If you do a test shoot, you can take some time to make adjustments before the big day. You'll also learn how quickly you can create the photograph. This can help you to be more efficient on the wedding day.

Another option for creating stand-out work is to stage a wedding. Come up with some great image ideas, purchase a used wedding gown, find a model, and play. This eliminates a lot of the pressure of having to create an image for a client and lets you work in a more relaxed manner. You might find wedding vendors who are willing to collaborate on these shoots in order to have access to the great images you take. A bridal gown shop may have discontinued dresses they will let you use. A hair and makeup artist may work with your model. A florist might create a bouquet for you. A jewelry designer may be willing to loan you jewelry for an image. In fact, you can even consider approaching a menswear store and getting a tux loaned to you so that you can have bride and groom models to create an even more realistic look. Doing shoots like this can help you learn, improve your skills as a photographer, and enhance your portfolio. You can also use these shoots to show potential clients your style and lead them to choose you as their wedding photographer.

Another great tip is to plan shoots every time you travel to a great vacation destination. Thanks to websites like www.model mayhem.com, you can look for models in the cities or countries you are visiting. Years ago, we started taking wedding gowns with

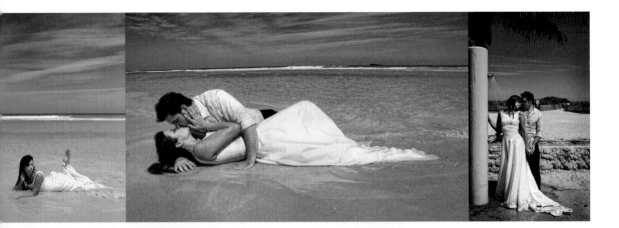

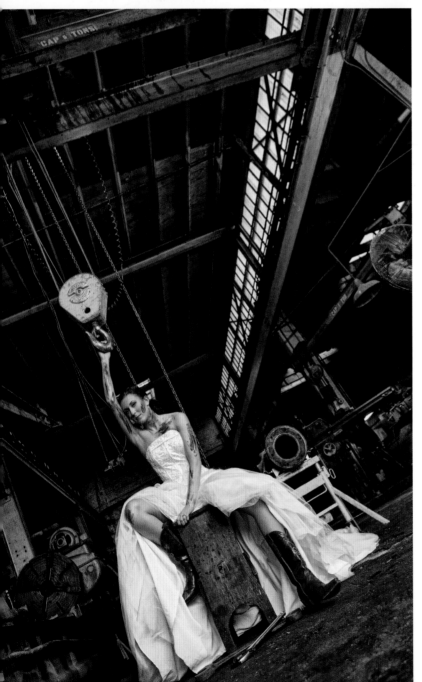

above—A trash-the-dress session can include both the bride and groom and create a fun opportunity for the couple to celebrate the marriage in a different way. *left*—A trash-the-dress session need not end in a ruined dress. This was something of a trash-the-bride session. We placed a white sheet under the bride to protect her dress from damage.

following page—You can create a beautiful and unique work of art during a trash-the-dress session if you take the time to scout out a great location, plan for the best time to capture the shot, and have the equipment you need to create it.

us on trips to exotic beach locations, and we began to arrange for a model to photograph while we were there. Creating images in areas that appeared to be outside of our local region attracted clients who were looking for destination wedding photographers. They could see just by looking at our images that we were willing to travel and had worked in places outside of our local vicinity.

If you are planning to buy gowns to travel with, choose ones that don't wrinkle easily. We look for gowns with lots of ruffles and chiffon in the skirt. Also, some fabrics are less prone to wrinkles. We use clamps as needed to tailor the dress to ensure a better fit for the model we are photographing.

Trash the Dress

Trash-the-dress sessions have been popular over the past decade. We've done many of them and can show examples to brides who are interested in such sessions. What we've found, though, is that most of our clients are drawn to these image because they prove that we are willing to do something fun and unique—not because they want to trash their gown.

There are a few points worth making about trash-the-dress sessions. First, you don't actually have to trash the dress. The point is to create a high-fashion-like im-

age of a bride in her gown in an area or situation in which you wouldn't typically place a bride. You don't need to get the bride in the water, smear mud or food on the gown, or set the dress on fire to achieve this goal. You just need to photograph her in a location that is considered *very* nontraditional for a bridal image.

Second, the gown that a bride or model wears for a trash-the-dress session is almost never the actual wedding gown. Most clients do the session in a used wedding dress. We

> *"If you are going to photograph a bride in water, keep in mind that wet gowns are heavy and hard to move in."*

have even purchased some second-hand gowns that can be used for such occasions. Of course, some subjects *do* opt to use their own gown; they see it as one more opportunity to wear a gown that they spent a lot of money on.

Trash-the-dress sessions appeal to brides who want something very different and like the shock factor. Some look at it as a way to celebrate the end of a long wedding-planning process; they want to have a little fun.

If you choose to do a trash-the-dress session, work smart. Start with poses in which the gown is completely dry or clean. If the bride will be getting in the water, get shots with her standing in water that is knee deep before she is fully immersed. Once she is completely wet, there is no going back.

Finally, safety should be your top priority. If you are going to photograph a bride in water, keep in mind that wet gowns are heavy and hard to move in. *Stay away from deep or rapidly flowing water.* Work in shallow water where the bride can stand up. It is also a good idea to have someone in the water who can help if the need arises. Also, *never* set your bride on fire! Yes, we've seen some dramatic images of brides wearing burning wedding dresses, but the odds of this going wrong are way better than them going right.

Trash-the-dress sessions demand great communication. Discuss any plans and con-cerns with your bride to make sure everyone is on the same page. Also, before planning your first trash-the-dress session, hire a model or friend to do a test run so that you know what to expect.

Fifteen Minutes of Fame

One of our studio's greatest sales points for booking weddings is that we get our formal group portraits done on the wedding day in about fifteen minutes, and often less. If you ask most couples to describe their least favorite part of the wedding day, the majority will say that it is the time spent doing group shots at the altar. Most of us have been in weddings in which these images take an hour or more—and we get bored fast. We get these portraits done quickly and efficiently so we can spend more time taking fun, creative photos with the bridal party on the way to the reception.

When we meet with our clients to plan the details of the wedding day, we outline a few basic rules that will ensure that we roll through this part of the day quickly. First, we explain that no one else should take photos during this time. Our packages include the digital rights to these images so that we don't have to compete with other photographers who are trying to capture group shots. Second, we do not take the group shots until all of the guests have left the church. This way, everyone can hear my instructions clearly, and people who aren't in

following page, top and bottom—By moving quickly through the formal portraits, you allow yourself more time to capture dramatic portraits of the bridal party and the bride and groom.

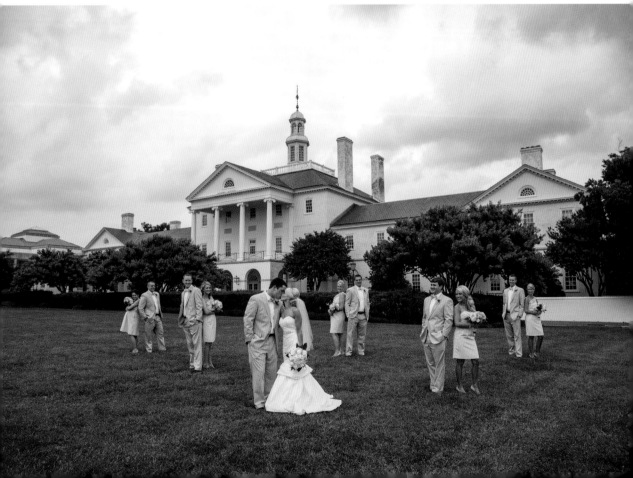

"Because I use this exact approach at every wedding, I don't need a shot list— I just follow my process."

the images aren't distracting those who are. Finally, we limit these images to the bride, groom, wedding party, and immediate family. We make an exception for Godparents or a member of the extended family who is like a parent to the bride or groom. Those exceptions usually result in one or two additional images and don't hurt my timing. (We are happy to photograph the extended family during downtime at the reception.) We usually advise the couple to have the ushers or groomsmen stay at the back of the church after the ceremony to make sure that guests do not make their way back into the venue.

If the reception will be held in the same venue where the ceremony took place, we scout, in advance of the wedding day, places where groups of portraits can be taken so the party and immediate family recess directly to that location. This allows us to start quickly with the formal group portraits, separated from the guests who tend to linger after the ceremony ends.

When we are ready to start shooting, I separate the groomsmen and bridesmaids. If there are seats or pews, I ask the men to sit on one side of the aisle and the women to sit on the other. I have them sit in the order in which they stood during the ceremony. This ensures that they are in the right order for the images. Next, I ask the family of the groom to sit directly behind the groomsmen

and the family of the bride to sit behind the bridesmaids. The more orderly things are at the start, the quicker the process.

From this point, I have a very specific shoot order that I follow. Because I use this exact approach at every single wedding, I don't need a shot list—I just follow my process. The only time I make a list is if there are a couple of images that are being added to my typical lineup. In that case, I glance at the list once I have finished capturing my standard images and take the extra photos at that time.

It is key to know in advance if there are any divorced parents on either side, if they have remarried and, if so, whether they are okay with being in the same image together or need to be photographed separately. You will also need to know if there are siblings from the new spouses. The more you know in advance, the more quickly you can get these images completed.

My standard group order is as follows:

- Bride and groom together at the altar.
- Bride and groom together with the minister.
- Bride and groom with bridesmaids, junior bridesmaids, and flower girls. (The ladies are evenly divided on each side of the bride and groom, with flower girls in front of the first bridesmaid on either side. If there is an uneven number of bridesmaids, the extra subject stands on the groom's side.)
- Bride with bridesmaids, junior bridesmaids, and flower girls.
- Bride and groom with the entire bridal party. (Move all ladies to the bride's side

in the order in which they stood during the ceremony and bring the guys up to stand beside the groom in the order in which they stood during the ceremony. Small children stand in front of first bridal party member on the side appropriate to them. I often take this image with and without the children.) After this image, I release all of the bridesmaids who are not siblings of the bride or groom to start gathering their belongings, and I ask the siblings to sit with their family members.

- Bride and groom with groomsmen, junior groomsmen, and ring bearer. (The men are evenly divided on each side of bride and groom with the ring bearer standing in front of the best man. If there is an uneven number of men, the extra subject stands on the bride's side.)

- Groom alone with the groomsmen, junior groomsmen, and ring bearer. After this image, I release all of the groomsmen who are not siblings of the bride or groom to gather their belongings, and I ask the siblings to sit with their family members.

- Bride and groom with bride's parents only. (The mother stands next to her child and the father stands beside the mother.)

- Bride and groom with bride's parents and siblings. (Both parents stand beside the bride, and her siblings stand beside the groom.) After this image is taken, the bride's siblings are free to gather their belongings.

- Bride and groom with both sets of parents. (Bride's parents remain where they are. The groom's mother stands beside him with his father beside her.)

- Bride and groom with groom's parents only. (Mother stays where she is. Father moves to the side of the bride.)

- Bride and groom with groom's parents and siblings. (Father moves back beside mother and groom's siblings stand beside the bride.) Once the image is taken, the groom's siblings and all parents are free to gather their belongings.

- Bride and groom with each set of grandparents. (In each case, the grandmother will stand beside her grandchild and the grandfather will stand on the opposite side. If only one grandparent is living, he or she will stand beside their grandchild. Each grandparent or set is photographed individually with the bride and groom, not as one large group of grandparents.) *Important note:* If the grandparents need help or a little extra time to make their way to the reception, I sometimes photograph these images at the start of the group-portrait session. In every case, I move the bride and groom down to floor level so the grandparents do not have to climb any stairs.

Consistently following the above formula allows me to quickly capture the required shots and makes for happy wedding parties, as we can more quickly move on to capture the fun photos and enjoy a more relaxed atmosphere. We've booked many weddings with members of bridal parties because they loved the results we achieved using this process.

previous page—Creating an image that fits the groom's persona and really shows who they are is something that will help you stand out from the competition. *right*—We often get so focused on the bride and her beautiful gown that we forget to take a great portrait of the groom. Make time to capture a great image that will help the groom and his family remember the day for years to come.

Don't Forget the Groom

As photographers on a wedding day, it is easy to become enamored with the bride in her beautiful dress, with wonderful hair, makeup, jewelry, and bouquet. The entire day is basically set up to draw attention to her, and most grooms are happy not to be in the spotlight.

The problem is that many photographers end up with tons of photos of the bride alone and the bride with her groom and often forget to take a few images of the groom alone. After a wedding many years ago, the mother of a groom called and asked if we had any images of her son that we had not shared with the couple. She said she loved all of the images and could not have been happier with the work we had done, but she saw so many images of the beautiful bride and none of just her son. We were crushed. She was right—we had neglected to take any images of her son by himself. Not only was this not fair to the groom's mother, but the bride probably would have loved to have an image of her new husband by himself as well.

This was the first and last time we ever made this mistake. From that wedding on, we have made it a point to take several great images of the groom by himself during the day. Our typical routine is to get one or

two great shots of the groom right after he has finished putting on his suit or tux and is ready for the wedding—perhaps a simple waist-up shot leaning by a window, sitting on the edge of the bed, or relaxing in a chair. This is when he looks his absolute best, and it only takes a few seconds to have him stand still for the quick snap.

Later, when we are out with the bridal party doing fun photos around town, we

above and following page—Having a simple set of poses that will allow the bride and groom to flow from one look to another in a single location gives you the ability to create a series of unique images quickly and easily. Changing the pose can be as easy as having the couple kissing and not kissing, having the groom nibble on her neck, having the couple look at the camera, look at each other, laughing, touching noses, etc.—without ever moving.

make it a point to take more stylish portraits of the groom alone in whatever environment we are shooting. At this point, we will capture full-length and cropped images of the groom and take photos of him looking at the camera as well as looking away. This gives the bride and groom and their families several portrait options to choose from. These images also make a great addition to the couple's wedding album.

Go with the Flow: Flow Posing

When you are photographing the bride and groom together on the wedding day, you want to make sure you have great images of them at the various locations. Having a standard set of poses that flow well from one to the next and using go-to poses at specific type of locations makes shooting quicker.

The key to successfully using flow posing is understanding that only minor adjustments are necessary. You might start with the couple standing close, holding hands, and touching foreheads while looking into each other's eyes; then capture images of the groom lifting the bride's chin gently with his hand; then have the couple share a soft kiss; then capture the action as he nibbles on her neck as she looks away and laughs; and finally have them cheek to cheek, looking at the camera and smiling. Those minor changes are made without altering the initial base pose and allow you to provide the bride and groom with a sequence of great images made in that location. In some cases, we may have the couple repeat the same set of six to ten poses at two or three locations. When the bride and groom select their favorite images, they might choose the kissing

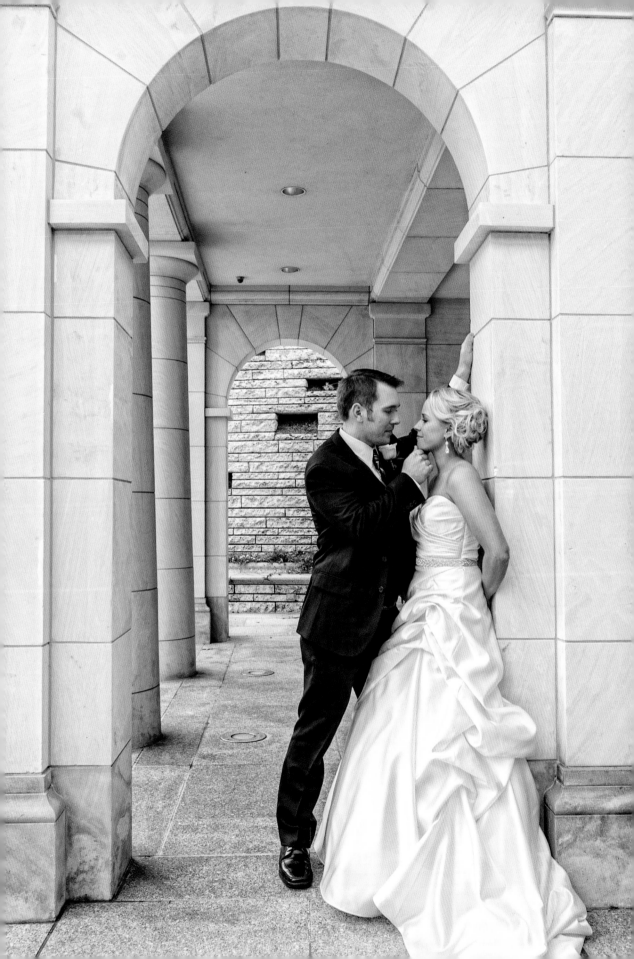

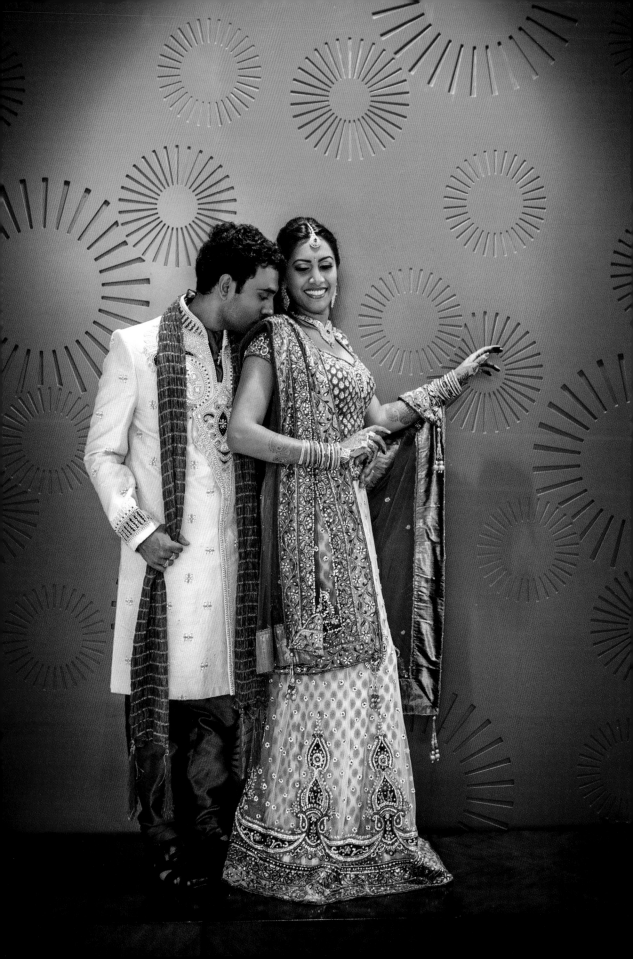

above and previous page—A seating area near an elevator is a location that most photographers walk right past. Moving a few things around may allow you to take advantage of a dynamic location with built-in spotlighting.

pose from one area, the cheek-to-cheek pose from another, and the touching foreheads pose from another. Each image will feel unique due to the different interactions within each pose.

We also employ certain poses for specific locations. For instance, we have a set of poses that we like to use on location that offer some visual depth, like a corridor or sidewalk area, where there is no real place to lean or sit. We rely on a one set of poses for leaning against a wall or standing in a doorway area and another for sitting down. Each time we work with a different couple and go through our standard set of poses, we try to do one new thing in at least one of the shooting scenarios, if not all of them. Sometimes the result isn't that great and we don't use that pose again; other times, we find something that we love and add it to the mix for future shoots. The beauty of flow posing is that it is constantly evolving.

Some photographers get bored with flow posing over time. We like to remind them that the process is new to their clients; they have probably never done flow posing before. Also, it is important to keep some level of consistency when you are shooting. This way, you have predictable results from one event to the next.

We occasionally have clients who say they want candid-feeling images with no posing. We start off by explaining to them that candid expressions and fun laughter in images is great, but our goal is to pose their bodies so that their physical interaction with each other doesn't look awkward and they look their personal best. We start with a basic pose and give them freedom to interact, laugh, and have fun so that they can get the feeling that they want in their images and look great at the same time. As they interact, we give occasional directions that lead to the poses we would use in flow posing anyway, and we capture the flow-posing images along with the candids that they want. This allows them to have the best of both worlds!

Passing By

We make an effort to not always shoot in the obvious spots at a location. Every wedding venue has an area that photographers love to use and brides love to have their portraits taken. We are generally happy to oblige and snap a quick shot of the bride and groom in those places, but we like to excite the couple with the prospect of having an image taken in a fresh new spot no one has used before. Being presented with the opportunity to create one-of-a-kind images excites most brides. More importantly, it allows us to

top and bottom left—With a few small adjustments, a seating area by the registration desk can turn into a dramatic setting for a bridal portrai. *top and bottom right*—Even something as utilitarian as an elevator can make for a stunning location. Take the time to pay attention to your surroundings and note their photographic potential.

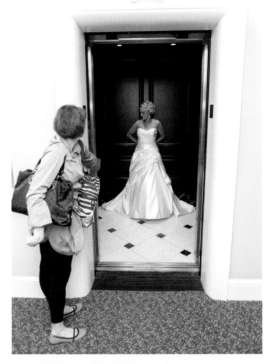

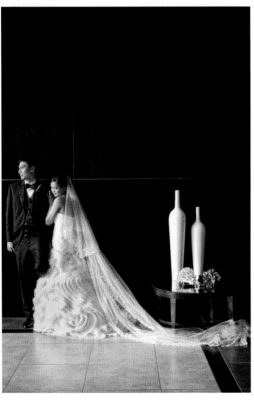

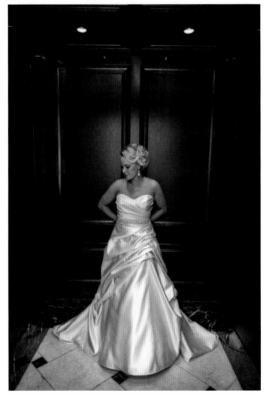

show images that don't look like those made by every other photographer in our area. The added benefit is that most venues are excited to share these images for us because they love for brides to see their space in a new and different way.

When we visit a space and start prospecting to shoot, we try to avoid looking at images taken there in the past. We don't want to be influenced by what is commonly done; we want to see a venue from a fresh perspective. We start by looking at the not-so-obvious areas—spaces in a lobby or seating area, nooks and corners, hallways, waiting areas, elevators, outside walls, and areas that have great wallpaper or paint. When we find unique spots, we try to imagine how we would place a bride or couple in that space so that it seems they belong there and the space was created around them. Randomly posing a person in a setting often looks forced and unnatural. Not every space and idea works, but when it does, it can be magic.

We have taken bridal portraits in elevators because the trim and design was so elegant. The images have been displayed as the main bridal portrait—the results are that great. An elevator is a space that most people only consider as a means to get from one floor to another. Because we are always thinking about the potential of any space for a cool image, we often find great new spots.

One of our favorite things to do is look low. Many photographers only pay attention to what is at eye level and miss great spots. We love to find floors that are shiny and reflective—especially if there is an adjacent wall with a cool design. If the bride or the couple are game, we will pose them on the

"The key to producing high-quality, innovative images is being aware of the potential for a great shot no matter where you are."

floor and use their reflections to create an elegant image.

Interesting light patterns can present opportunities for striking images as well. Look for spots where light from a fixture creates linear designs that form a natural vignette or create a geometric design that guides the eye to your subject(s).

It is the ultimate compliment when we see our images duplicated by other photographers. Not only does it mean that we have captured a successful image, but it also forces us to look for ideas for that next new and different image so that we can stay one step ahead. The key to producing high-quality, innovative images is being aware of the potential for a great shot no matter where you are, never limiting yourself to the immediate area you are working in, and never being afraid to explore new areas in old spaces.

All About the Small Stuff

Great details make a wedding unique. We absolutely love cultural weddings that incorporate color and tradition into their ceremonies. Every little item used during the ceremony has a purpose and meaning, and being in a room full of such details is like being a kid in a candy store—you don't know where to start shooting because it's all so decadent! Since we are well prepared for the wedding

and generally know what to expect, we are ready with an arsenal of lenses, lights, and props to enhance our images.

Early in the day, when we capture the final stages of the bride and groom getting ready, we focus on what they chose to wear that day—the dress, tuxedo, shoes, veil, and jewelry. We also look to capture images of anything that may be a special heirloom, a gift from the family, or something made for that particular day. We ask our clients to have those items ready when we arrive so we can stage them in a flattering way. Every little thing that surrounds us can be beautifully captured and used to preserve memories of that special place and time—so we stay alert to our creative options.

We do not always have a big, clean room to photograph in. Sometimes the location is like a dorm room that is exploding with

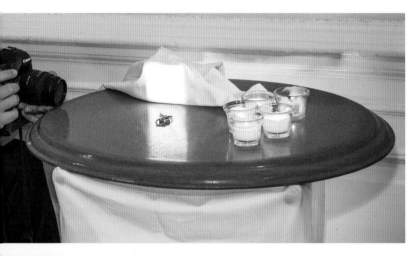

A reflective surface like the bottom of a serving tray or a candle plate on the dinner table can make a great backdrop for a detail image.

Incorporate some of the wedding props in your detail images to create a striking photo.

clothes and personal items. If we can help it, we recommend that the key moments be photographed in a neat room with ample light to ensure there aren't any unflattering distractions. If there isn't much available light, then we bring out portable lights for more flattering effects. We also bring fast lenses for low-light situations. Most clients are happy to comply with our wishes, knowing the results are sure to be spectacular.

If you find yourself standing beside guests who are taking the same photographs you are, find a unique perspective to shoot from to ensure your images stand out.

Find Unique Angles and Perspectives

It seems that everyone at every wedding we shoot now has a camera, whether it's a cell phone, point & shoot, tablet, or DSLR. This presents two problems for professional photographers: we must make sure those people are not in the way, and we must produce images that stand out from the guests' images.

There are times when the best way to capture an image is to hold your camera and shoot from a normal perspective. However, we often find ourselves shoulder to shoulder with guests capturing moments from the same angle and perspective. We feel confident that our images will be stronger than theirs because of the quality of the camera and lenses we use, the lighting we have brought with us, and our ability to make creative adjustments. Even though we have that confidence, we do what it takes to create a unique shot. It can be as simple as squatting down to get a lower vantage point, grabbing a chair and stepping up for a higher perspective, finding items to use in the foreground to give depth to an image, or shooting through objects to frame a moment. As professionals and artists, our clients look to us to see things differently than the guests and create something fresh and unique.

Creating stand-out shots is particularly important during key moments of the day. For example, during the first dance, we sometimes go so far as to pre-focus on the bride and groom and lock the focus in based on the distance they are from us, then put the camera on the dance floor with a very wide angle zoom and take a series of images without looking through the lens. We tilt the camera up and down slightly to make sure we have a few image options. This approach usually gives us a nice reflection of the bride and groom on the dance floor that leads the eye to the bride and groom dancing in the frame. (In general, getting this reflection works best when we turn our strobes off and bump up our ISO to capture only ambient light. It looks even better when there is perimeter lighting.) It is great to capture the entire scene from that perspective. On occasion, there is a first-dance spotlight on the bride and groom, and we are able to capture the same image with light behind the couple so they are silhouetted for dramatic effect.

At times, we like to use a technique referred to as "fish on a stick." A good friend, photographer Kevin Hurley, showed us this trick many years ago, and we have since enjoyed using it while photographing weddings and sporting events. We place our camera on a monopod with a fisheye or super-wide-angle lens and have a remote trigger attached to it, which we can fire from the bottom of the tripod. We prefocus from the ground level, then extend the monopod so that the camera is five or six feet over our heads and fire as we pan to get photos from a bird's-eye view. This approach works great with flash or a good video light on the hot shoe so you can be sure the scene is well lit. It is an effective technique for capturing dance floor candids, the cake cutting, and any moment when you have large crowds of people in one place and want to show everyone in one shot.

Looking for elements of the wedding to anchor a moment and create depth of field gives your images a unique, creative feel.

During the ceremony, we often work with the church to find angles and spots from which we can shoot and not be a distraction to the guests and bridal party. Quite often, we find a church that has a choir loft behind the altar. There is usually a side entrance on both sides where the choir comes in. Shooting from this location provides a great rear, side-angle view of the bride and groom as they say their vows. The problem is, you can't open the door during the ceremony, as people will notice that happening. Also, you need to make sure there is a way to get to that door without being seen. We have found that placing a 6-inch 2x4 board in the door creates a wide enough opening to shoot through. We simply place the block in the door in advance so that we can just stand right outside that door and get our shots. While Liliana works from the balcony or the back of the church, once the bride has walked down the aisle, I walk outside the church to a rear entrance that gives me access to the choir door without ever being seen by the guests. If you opt to take this approach, be sure to clear the plan with the church staff, and make sure you have time to get to the spot, get a few shots, and get back to your original spot before the kiss.

Putting effort into ensuring a creative, high-quality capture will result in unique images and make for happy clients.

Great Reception Room Shots

Since we have already discussed the timeline with the wedding planner and our clients, we know there is time to photograph the room before guests enter. We start by photographing the large room as a whole, then we close in on the details. We capture the small details on tables last, as it doesn't matter if there is a large group of people nearby—we can zoom right in to the item.

Capturing great room shots not only shows the bride and groom that you take time to document every aspect of the wedding; it also provides the vendors who created the signature look a great image to use in their marketing, and your company name is attached to it.

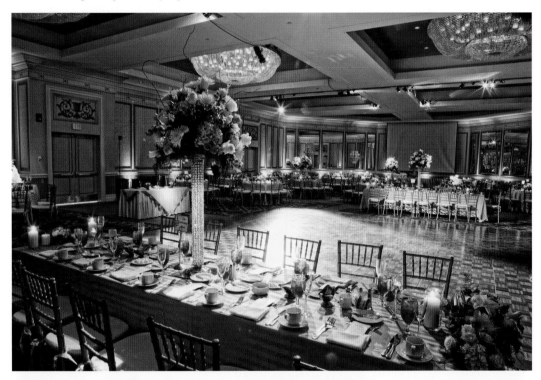

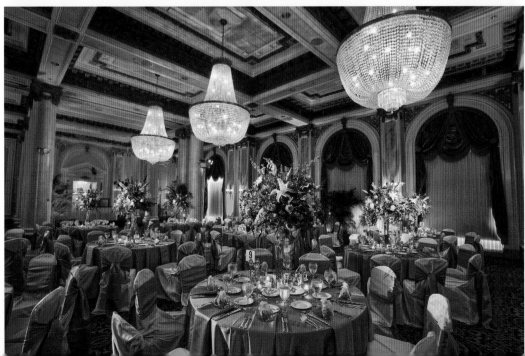

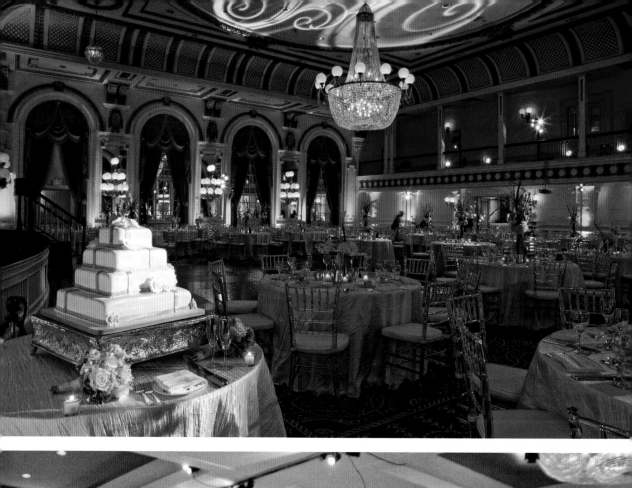
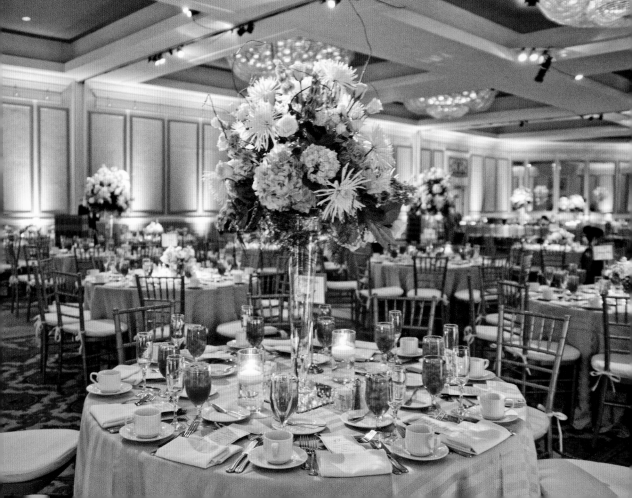

If event lighting is not available, we use our small lights and point them toward the centerpieces to accent the flowers and add ambiance and a warm glow to the room.

We photograph the room from every available corner to allow for more perspectives. Everyone is sitting at various locations, so what one guest sees is different from the view of a guest who is seated across the room in the opposite corner. We like to capture everything from high and low angles so that we can present a kind of virtual tour of the room.

Next on the shot list are individual table shots, then chairs and place settings, down to the special napkins, menus, or favors placed at each setting.

"Great room shots are extremely valuable to the venue, as they like to showcase their beautiful events and talented staff to all their prospective clients."

Great room shots are extremely valuable to the venue, as they like to showcase their beautiful events and talented staff to all their prospective clients. Providing the venue management with beautiful images they can use to book a client will surely get you on their preferred-vendors list.

previous page, top and bottom—Often, the bride and groom are the last people to enter the ballroom and never get to see what it looked like before the guests filtered in. Taking the time to capture the room for them allows them to experience a part of their wedding that they missed.

5. THE POST-WEDDING PHASE

Products

You have to show it to sell it, so having products beyond prints, such as albums, can greatly boost your income. Most of our collections include an album for the bride and groom, but only the top-tier collections offer a small album for the parents. All other albums are considered custom add-ons. Our best sellers over the years have been engagement signature books and parent albums.

Engagement sessions can generate a lot of revenue. Our clients often purchase loose prints, save-the-date cards, various announcements, and a signature album featuring their images, which guests can sign at the reception. We limit the number

previous page—Finding a selection of albums and products that cater to your ideal client and reflects your style is important. *below*—Creating a high-end, professionally designed album for your client gives them a family heirloom to pass on to future generations.

of images they can choose and have a set template for the standard number of pages the signature album will be, so our cost and the time it takes to create the album are predictable. Of course, anything beyond the standard products we offer are considered custom and come at a higher price. To keep our production costs down, we opt for peel-and-stick albums with various color options. We are able to print and stick the pages to the album ourselves. It is important to price these items appropriately, taking into consideration your album cost, the cost of printing the pages, and the time to lay out and design the pages.

Parent albums come in a variety of sizes, color options, and designs. Many of the parents we work with choose traditional matted albums. These are easy for us to create, as there is no actual design work required; we simply print the chosen images and add them to the mats.

Because albums are considered an heirloom, we can price them considerably higher than we would price the same number of loose prints. We provide a professionally designed album, which most clients would not be able to create themselves. We also offer digital-style albums, which have a more modern look. We design these albums with the clients' chosen images. This process takes a great deal of time to complete and requires expertise in Adobe Photoshop. Always remember that your time and experience are valuable and set your prices with that in mind.

Save-the-date and thank-you cards are popular but not as profitable as the custom products mentioned earlier. If you have really great designs to offer, your clients may prefer that you design and print their cards. This can be nice if you are able to find a lab that will print them at a low cost. These days, however, many clients go the DIY route and create cards using websites that offer card-printing services. Remember that unless you have sold the digital files to your clients or are providing them free of charge, you should charge a fee for the image usage.

Image Enhancements

Most photographers like to use actions and software plug-ins to add effects to their images before presenting them to clients. It's a great way to take an ordinary image to the next level. We have created a few actions that we like. We also use the Nik Software suite of plug-ins.

When using these tools, always start with a high-quality image—one that is well

left and following page—Often, simple effects like a cross-processed look or a mocha-toned black & white can be simple, elegant touches to a photo. The key is to have three or four effects that you consistently use on your images so that you develop a signature look.

exposed, artfully composed, and has good lighting. You have a lot more creative flexibility in that case.

We shoot in RAW because it allows for more latitude in enhancing the image in the post-processing phase. If our camera settings are a little off, we can often salvage an image. We can better recover detail in highlight and shadow areas (like the gown and tuxedo!).

In postproduction, less is more. If you have forty or fifty actions, you don't need to use them all. We found three or four looks we loved early on and have consistently used them when processing our images. This helps us to create a signature look and feel that our clients and prospective clients recognize. If we use too many different actions and plug-ins and create too many different styles in our image galleries, clients won't recognize the images as ours. Over the years, it has been flattering to have a client call or message us and say, "I saw some of your images in a friend's house the other day. I knew they were yours without having to ask them."

We are purists at heart and believe that if you have a strong image, the quality of the original image should be enough to enjoy. That said, there are actions and plug-ins that we like very much and use—but only with a light touch. We like Café Mocha, an action that lends a slightly toned black & white effect with a mild vignette. Vignettes are almost always overdone. A successful vignette should provide a slight darkening of the perimeter of the image that draws the viewer's eye to the center of the image, where the subject is. An overdone vignette detracts from the subject. We also use a cross-processing filter for some of our natural light images (used with the lightest touch!) to brighten them up and give them a more lively feel. Another favorite tool is the Nik Color Efex Pro Tonal Contrast filter. It allows us to add an extra pop of sharpness and a slight increase in saturation for enhanced impact. When we apply the filter, we reduce the opacity of that layer to 25 to 50%.

When you consistently create images with a signature look and employ a strong marketing approach, people will seek you out to create images with that look and feel for their wedding.

Online Sharing

Finding the right Internet sites is key to sharing your amazing wedding images with future clients and vendors. Many companies host password-protected online galleries. Some charge a monthly or annual fee. Others charge a fee for each item sold (they usually take a percentage of the sale).

During the first few years of online posting with Collages.net, we would display at receptions an elegant informational sheet next to the guest book or engagement signature album. This let guests know that the wedding images would be posted online after the wedding and that, if they provided their e-mail address, we would notify them when the gallery was live. The guests visited

Online gallery services are a great resource to use not only for sharing the couple's images with their friends and family, but also to increase your sales of loose prints to those same viewers.

the gallery and many ordered prints of themselves, their family members, and often large prints as gifts for the wedding couple. We saw thousands of dollars in orders filter through, without us having to take any orders. It was all done seamlessly online, and the funds from the sales were funneled directly into our bank account.

The online galleries have become a wonderful place for prospective clients to see the complete coverage of various weddings in a nice, organized fashion. We are able to direct future clients to image galleries created at their venues, which is immensely helpful if you don't actually have a physical sample

album to show them when they meet with you. We also direct vendors to the galleries to select images they would like to use in their marketing. Additionally, they are able to see a complete wedding. This way, they can see that we have talent, and they will hopefully generate referrals.

We use other sites primarily to share images with vendors and publications. With a membership, some sites allow you to upload albums with images that can be sent directly to publications calling for particular weddings and details. A site we use for this service is Two Bright Lights, which provides these benefits with a monthly membership.

In everything you do, from capturing your images to how you market yourself to your clients, you are rarely going to be the first to do anything. However, you can always add your own personal twist.

(Note: Free basic memberships are also available.)

When researching which sites will be best for showcasing your images and reaching the public, consider the benefits and the investment required. Also keep in mind that these sites should be easy for you and your viewer to navigate.

Add Your Own Twist

Adding effects with actions or plug-ins is not the only way to cultivate your personal style and create work that stands out. You will also need to create a unique brand. Companies like Pepsi and McDonald's spend millions of dollars each year to research what marketing ideas—everything from specific fonts, to colors, to ad layouts and designs—will attract customers. One way to draw attention to your work is to identify the brands that you think best target the clientele you hope to attract and utilize some of those elements to create your own brand.

We try to routinely pick up copies of magazines that our target clients might buy and look at the design elements of the ads in them. We've seen many common design elements across several ads, and some colors and fonts seem to be consistently used by several companies. We create ads that feature some of those details. We also look at the images used in the ads and make note of the posing and the processing style to see what photographic trends are being presented to the clients we want to reach. Using these cues is incredibly important.

When we take inspiration from recent magazines, we are able to stay current. Too many companies are afraid to change or too lazy to make the effort. Now, doing some research and fine-tuning your approach does not mean you need to scrap everything you have done; in fact, that would be a huge mistake if you have an established business. We have always tried to make sure that certain key elements from our advertisements and branding roll over to a new look and feel so that we still have some solid recognition with our existing client base.

The great benefit of analyzing and refreshing your marketing materials each year is that you can use images from recently completed weddings and create a fresh, polished look.

Be a Storyteller

As photographers, we have to remember how much of an honor it is to be asked to capture one of the most important events in a person's life. We need to try to not take this responsibility lightly. It is important that we let our clients know they we understand

it is big day for them, and we won't disappoint. The moment we start to punch the clock—to show up for the alloted hours and shoot the wedding, counting down until it's time to leave—we have lost our passion for shooting weddings. There are photographers who run a volume-based studio; their entire approach may be to get in and photograph as many weddings as possible. Even those photographers must recognize that their client entrusted this important day to them, and lots of other photographers could have been selected.

The fact is, some brides hire a photographer based not on emotion but on budget and what they will get for their money. Even so, we are storytellers. Our job is to not just snap photos of random moments of the day, but to capture the essence and spirit of the clients' wedding day. These are the images that they will look back on to remember the emotion, laughter, joy, friends, and family— all of the moments that only happen once in their lifetime. We need to shoot with one part creativity and one part heart. As long as emotion is our guide, the end product will be a thing of beauty.

We must also be ready to capture a moment at any time. You never know when the next great opportunity will present itself, and if your camera isn't within arm's reach,

"We have to remember how much of an honor it is to be asked to capture one of the most important events in a person's life."

above and following page—Whether it's a special moment the couple shares on the wedding day or a close relationship between her mother and her daughter, it is our job as photographers to create not just images, but also to document moments and memories.

you might miss something that will never happen again.

We are image makers, documenters, and storytellers. We don't use a pen to tell the story or a brush to create our art; we use a camera. Do all you can to get lost in the moment. Forget about what is happening in your life and give yourself to your client. Put what is going on in their life first.

If you do these things, success and money will follow because your love and passion for this business will shine though.

CONCLUSION

The reality is there is no one perfect formula that works for everyone. There are many factors that will affect whether your wedding photography business is successful; region, style, products, support, etc. The best we can do as professionals is throw a pebble in the water and hope that the ripples it causes become a tidal wave of success. If that doesn't work, then we just throw more and different stones until we find what works for us. In life and in business, the only place success comes before work is in the dictionary, so you have to put in the time, research, and work to have success in your business.

If you are reading this book, then you are taking a huge step in the right direction, not because this book holds all of the answers, but because this book represents your desire to educate yourself on things that will make you better. Regardless of how much success you have in your business, never settle; you never know when the next recession might hit or a major trend shift will happen. If you don't continue to look for ways to grow and improve, you may not be ready for those industry changes. Our hope for every reader is that they never reach their peak as a photographer because they never stop growing!

previous page—The only place you will find success before work is in the dictionary. Use the tools in this book and other lessons you learn and put them to good use to help your business grow.

INDEX